IMAGES
of Rail

McKinney
Avenue Trolleys

To Phelps

Jim E Cobb

Judy Smeth Hearst
a very long-time
Supporter + Friend
to State-Thomas

IMAGES
of Rail

McKinney
Avenue Trolleys

Jim Cumbie
Phillip E. Cobb

State-Thomas Neighborhood Overview
by Judy Smith Hearst

ARCADIA
PUBLISHING

Copyright © 2011 by Jim Cumbie, Phillip E. Cobb, and Judy Smith Hearst
ISBN 978-0-7385-8497-3

Published by Arcadia Publishing
Charleston, South Carolina

Printed in the United States of America

Library of Congress Control Number: 2011927147

For all general information, please contact Arcadia Publishing:
Telephone 843-853-2070
Fax 843-853-0044
E-mail sales@arcadiapublishing.com
For customer service and orders:
Toll-Free 1-888-313-2665

Visit us on the Internet at www.arcadiapublishing.com

This book is dedicated to McKinney Avenue Transit Authority's (MATA) supporters and staff—Dallas Area Rapid Transit, the Uptown Public Improvement District, the board of directors, volunteers, and paid employees, whose dedicated efforts have kept MATA's vintage trolleys running reliably for over 20 years in Uptown Dallas.

The State-Thomas chapters are dedicated to the Friends of State-Thomas, Preservation Dallas, the Uptown Public Improvement District, City of Dallas Planning staff, Tax Increment Finance District Board, and, most of all, to the remnant of "North Dallas" property owners and urban pioneers who, with love and dedication, persevered over decades for the preservation and redevelopment of today's unique neighborhood, State-Thomas in Uptown.

CONTENTS

ACKNOWLEDGMENTS

We wish to thank all of the MATA volunteers and supporters for contributing their photographs for this book. We are also especially grateful to Johnnie J. Meyers for his kindness in allowing us to use a few of his photographs. Many photographs are credited to the MATA Collection or the Jim Cumbie Collection. In these cases, there is no identification of the photographers. These anonymous shutterbugs all deserve a special thanks, whoever they are. In chapters seven through nine, unless otherwise noted, all photographs were taken by Jim Cumbie.

For the State-Thomas chapters, thank you to all who generously shared their photographs, including Patricia Meadows, Joe Kirven, Virginia McAlester, Steve Clique, and the collections of the Texas/Dallas History & Archives Division, Dallas Public Library, and the Dallas Historical Society. And special thanks to the Uptown Dallas Inc. Archives for allowing us to use their State-Thomas collection, to Nancy Starr for supporting this project, and to friends and neighbors who have shared their precious keepsakes and memories.

INTRODUCTION

The horsecar boom of the late 19th century changed American cities. The average person no longer had to live within walking distance of his place of work—now he could easily and quickly commute to work. Cities grew, and suburbs sprang up. However, horses (or, in Texas, mules) ate when they were not working, and a more economical source of propulsion was sought. One early idea was to utilize small steam locomotives (disguised to prevent them from scaring horses) to pull one or more horsecars in city streets.

The first practical scheme to harness steam power was the cable car. A central powerhouse drove a continuously running cable in a trench below the street and between the tracks. A device controlled by the driver gripped the cable to tow the car along, or released it to stop. At their peak, cable cars once ran in 27 US cities. A proposed cable line for Dallas was never built.

Cable cars solved the steam-power problem, but they were labor intensive. In an attempt to come up with less expensive options, many ideas—some ingenious and some downright weird—were proposed to power streetcars, but electricity won out as the only practical means of propulsion.

The problem, though, was how to get electricity to the streetcars. Inventor Leo Daft's electrified horsecars drew power from two overhead lines on which rode grooved, four-wheeled trollers connected to the cars by a wire. The word *troller* eventually evolved into the word *trolley* for the current collector and later for the cars themselves. (Daft's system never achieved any satisfactory degree of reliability.)

Frank Sprague pioneered the practical electric trolley car by inventing an ingenious design for mounting the electric motors on the axles of the streetcar trucks. In 1888, Sprague opened his first trolley system in Richmond, Virginia. His cars used a practical, rigid, spring-mounted pole with a small wheel at its end that collected current from a single overhead wire. Richmond became famous for having the first successful trolley system in the world and spawned similar street railways all across the globe.

From then on, more and more trolley lines were built across the country. There seemed to be no end to their growth. Also, many electric interurban lines were built to connect cities and towns to one another. However, by 1940, the private automobile, the motorbus, and the electric trolley bus had made significant inroads on the once vast network of trolley lines in many cities and towns. In addition, some claim that National City Lines, allegedly owned by General Motors and a consortium of gasoline and tire companies, began a systematic purchase of transit companies all over the country with the purpose of replacing trolley lines with motor buses.

Dallas streetcars escaped that fate, as the locally owned transit company Dallas Railway & Terminal Company (DR&T) kept faith in its electric trolleys. Although there had been a few previous conversions of trolley lines to buses, by 1945, DR&T was still operating 251 streetcars over 18 lines. In addition, the Texas Electric Interurban Railway was running between Waco and Denison through Dallas. Elsewhere in the state, trolleys were few and far between: Waco and El Paso had single lines, an interurban connected Houston and Baytown, and a short, electric-powered freight railroad ran in San Antonio.

However, 1947 signaled the start of the decline of Dallas streetcar lines, as they were gradually replaced by motor and electric trolley buses. Only 121 streetcars remained in the fleet three years later. The 1950s were not kind to rail systems nationwide, as aggressive lobbying diverted all federal funds to the building of superhighways and freeways as a solution to traffic problems. Anything on rails was considered old-fashioned and obsolete. It was even thought that railroads themselves were a vanishing breed. Finally, victims of this frenzy of modernization, the last Dallas streetcars ran in January 1956.

However, increasing traffic congestion, escalating gasoline prices, air pollution, and concern for the environment gradually turned America's attention to a new type of trolley: fast, modern electric cars that could operate in a variety of environments. The new light rail movement began in the 1980s with successful systems in San Diego and Calgary and gradually spread across the country. And city governments came to the realization that vintage or modern streetcar lines were the keys to improve urban mobility. The electric trolley car, once so despised, was becoming the vehicle that was moving America forward into the 21st century.

STATE-THOMAS

Who would have imagined when early Dallas pioneer Col. James Thomas bought a 40-acre tract of land north of town in 1868 that it would someday become today's much-desired State-Thomas neighborhood in Uptown Dallas?

Who would have imagined that at the same time, six blocks away, newly freed slaves gathering around their ancient burial grounds would create Freedman's Town and in a few years have homes, churches, their own educational system, and a new future for themselves—carved out of nothing?

Who would have imagined that the first mass transit a few years later—the mule-drawn trolley on McKinney Avenue—would inspire the first suburb in Dallas, a neighborhood of prosperous business owners and visionaries?

Volumes could be written about these two interdependent, yet seemingly disparate neighborhoods, born side by side—the prosperous business owners on one end and ex-slaves seeking opportunity off the farm on the other. The intent in this book is to tell just a bit of the rich, colorful time of the first prosperous business owners, to the robust and exciting African American times, to the very diverse walking neighborhood of today.

From its beginning until today, neighbors have coexisted in close proximity, building the future.

One

THE FIRST STREETCAR ERA

THE GROWTH YEARS

In 1872, the Dallas City Railroad Company opened a mile-long streetcar line on Main Street, using two cars pulled by mules. The Texas & Pacific Railroad's arrival the following year spurred the city's growth. By 1886, the city's population had grown to 25,000, and four mule-drawn streetcar lines were serving the city with nine and a quarter miles of track.

In the following year, two steam-powered lines were built, one of which connected Dallas with Oak Cliff, across the Trinity River. The first electric trolleys debuted in 1891, and by 1902, they had completely replaced all of the mule- and steam-powered lines. The trolleys gave the average person a way to live outside of the downtown area and commute to work quickly and comfortably.

The Dallas streetcar system was a hodgepodge of some 20 companies that, over the years, merged with one another and eventually, in 1917, into a single entity, the Dallas Railway Company. The Stone and Webster Company owned various streetcar systems in Dallas until 1917. Their turtleback-roof design influenced Dallas trolleys for many years.

In addition to its extensive network of trolley lines, Dallas became the hub of three intercity interurban lines—the largest single interurban system between the Mississippi and the West Coast. The most successful of these, the Texas Electric Railway (TERy), also operated local streetcar service in many of the towns and cities it served, including parts of Dallas. TERy also developed a profitable freight business.

Because it owned the interurban terminal building, Dallas Railway changed its name to Dallas Railway & Terminal Company (DR&T) in 1925. In the same year, motorbuses first made their appearance. And in 1925, the Texas Electric Railway sold its streetcar lines in Oak Cliff to DR&T.

Although the Great Depression, the private automobile, and improved bus technology all combined to reduce transit patronage and spell the end to streetcars in many American cities, the locally owned network of Dallas trolley lines remained largely intact. By 1940, Dallas was the only city in Texas with a streetcar-based transit system.

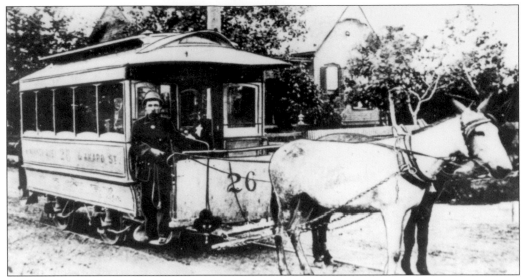

The first Dallas street railway, the Dallas City Railroad Company, was chartered in 1871. The 1.5-mile line on Commerce Street began operations in 1872 with two cars, the Belle Swink and the John Neely Bryan, both pulled by Mexican mules. Advertised time for the round-trip was 30 minutes. (Texas/Dallas History & Archives Division, Dallas Public Library.)

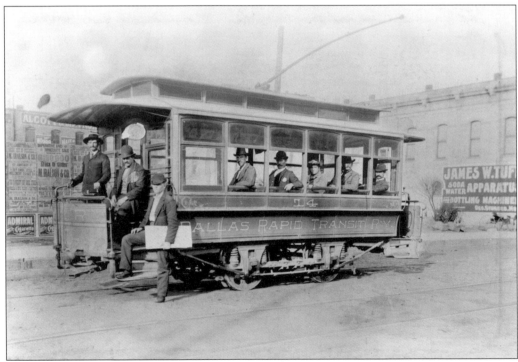

The Dallas Rapid Transit Railway, connecting downtown with the fairgrounds, began as a steam-powered line in 1888. It opened in time to help carry the immense crowds attending the fair. The company soon replaced their little "steam dummy" engines with the new modern marvels—electric trolley cars—in 1889. (Texas/Dallas History & Archives Division, Dallas Public Library.)

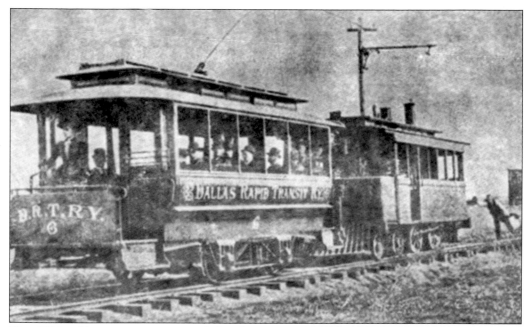

This 1890 publicity image was intended to demonstrate that the new electric car is so easy to run that "even a woman can operate it" and that the trolley is towing the steam dummy so fast, its unknowing engineer has been left behind and unable to catch up with his locomotive. (*Southern Traction*, April 10, 1973.)

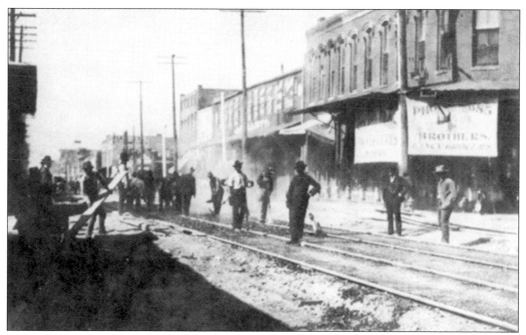

Around the turn of the 20th century, Dallas was caught up in a building boom of new electric streetcar lines. However, building them often involved a considerable amount of manpower and hard work, as illustrated by this scene of track being laid on Elm Street in 1896. (Texas/Dallas History & Archives Division, Dallas Public Library.)

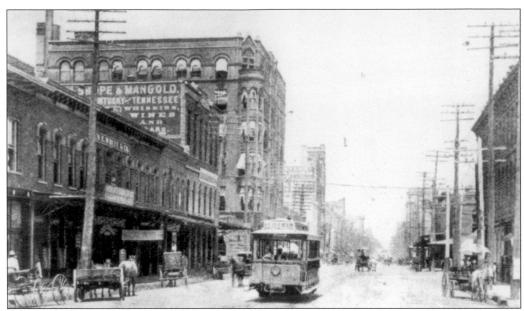

In 1900, a little trolley is seen rolling down Elm Street in downtown Dallas. Even though the early trolleys suffered from some technical problems, the revolutionary impact that they had on urban mobility is demonstrated by the fact that the electric car appears to be the only mechanized vehicle on the street. (Texas/Dallas History & Archives Division, Dallas Public Library.)

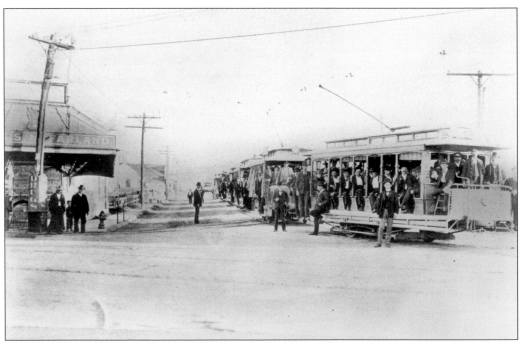

In 1906, members of the Dallas Chamber of Commerce rode to the Texas State Fair on board several trolleys. It is not known if this was a charter or if the trolley company rolled out extra cars to handle the crowd. Every car in the lineup seems to be filled to capacity. (Texas/Dallas History & Archives Division, Dallas Public Library.)

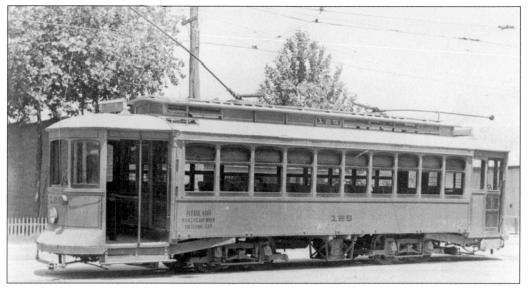

As trolley lines grew, so did the cities they served. As passenger loads increased, it became necessary to replace the original horsecar-size trolleys with new, larger ones riding on a pair of four-wheeled trucks. This Dallas car was built in 1906, apparently a year of innovation in streetcar design. (Jim Cumbie Collection.)

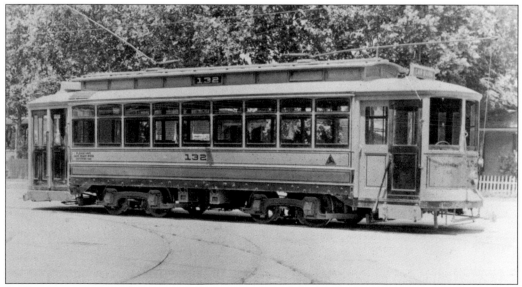

Trolley 132, one of six identical cars, was a type of streetcar known as a deck roof car. Cars 130–135 were also built in 1906 but were rebuilt in 1910. Trolley 134 was retired after being in a wreck in 1919, and its sister car 135 was scrapped in 1940. (Jim Cumbie Collection.)

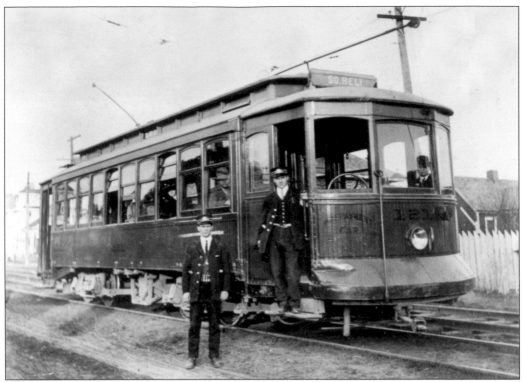

The crew of trolley 121 poses for a photograph typical of the times. This car, another product of 1906, was rebuilt in 1918. The big wheel seen inside the front window controls the handbrake. The car also sports a coupler on the front, indicating it might have been intended for multiple-unit operation. (Texas/Dallas History & Archives Division, Dallas Public Library.)

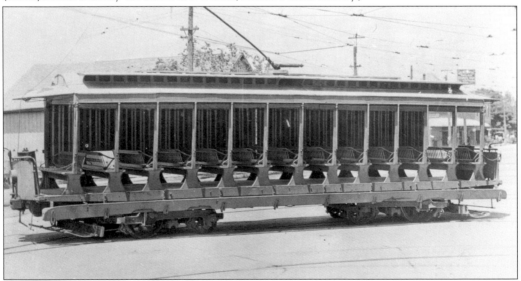

With the advent of air-conditioning decades away, open cars, such as this one photographed in 1908, were very popular in the summer. Trolley companies liked them too, as they facilitated fast boarding and loading at special destinations, such as the Texas State Fair and the baseball park in Oak Cliff. (*Southern Traction*, April 10, 1973.)

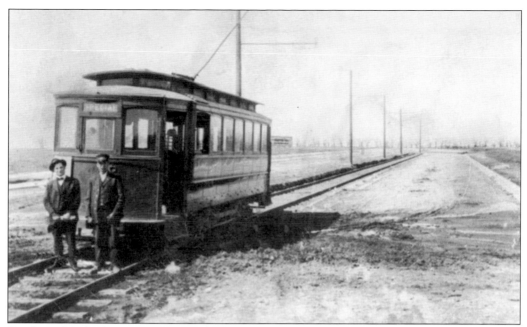

Southern Methodist University was built beyond the northern Dallas city limits. Beginning in 1915, a shuttle trolley connected the school with an existing line to Highland Park. Eventually, the SMU line ran from downtown on McKinney Avenue, Bowen Street, Cole Avenue, and on the edge of the campus alongside Hillcrest Avenue. SMU's Dallas Hall would be to the right of this view. (Park Cities Bank and Trust.)

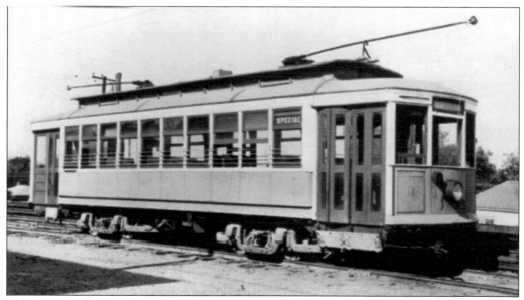

This Dallas trolley number 206, built in 1909, was a group of 12 leased from Fort Worth's Northern Texas Electric Company (NTEC) in October 1917. NTEC was a Stone and Webster property that operated the local streetcar lines in Fort Worth. The Fort Worth streetcar system was abandoned in 1939. (Jim Cumbie Collection.)

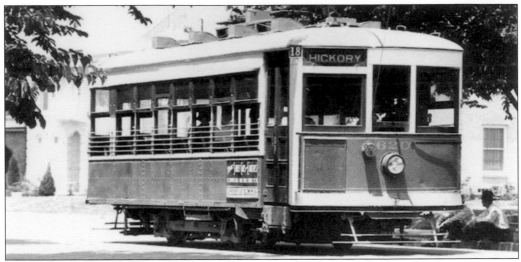

Not all new trolleys were big. In 1918 and 1920, Dallas Railway bought a total of 62 lightweight Birney cars that were designed for one-man operation and were economical to run, as they used less electricity. These trolleys were infamous for their bouncy, uncomfortable ride. In Dallas, they were known as "Dinkies" and were not very popular with riders. (Walter H. Vielbaum, McKinney Avenue Transit Collection.)

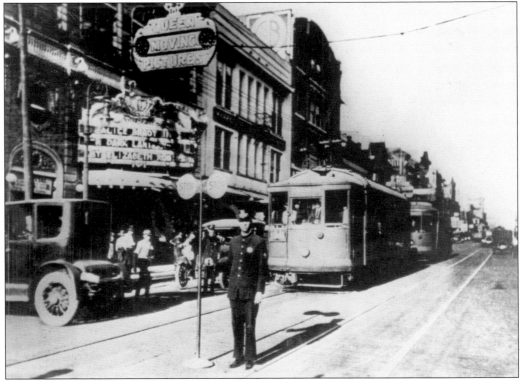

This 1920 downtown Dallas scene shows that the automobile is starting to make some inroads on the traffic scene. However, the trolley is still the first and most convenient choice for mass transit. The intrepid policeman stands in the middle of the street directing traffic with a rotating stop and go sign. (Texas/Dallas History & Archives Division, Dallas Public Library.)

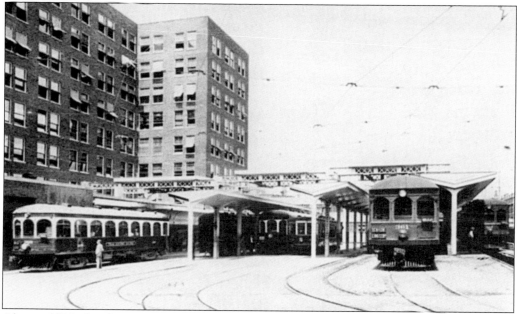

Also in 1920, the downtown interurban terminal was a very busy place. The Texas Electric Railway, the Northern Texas Traction Company, and the Texas Interurban Railway Company all shared what was the most impressive interurban terminal between the Mississippi and the West Coast. It first opened in September 1, 1916. (Texas/Dallas History & Archives Division, Dallas Public Library.)

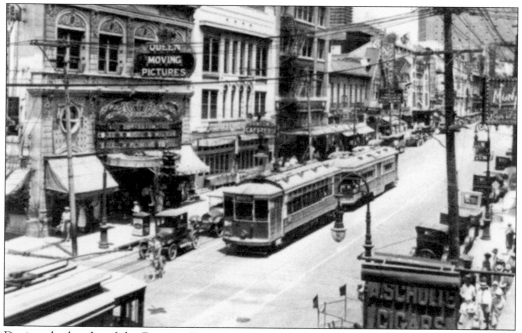

During the height of the Roaring Twenties, Henry Ford's mass-produced automobiles lined the downtown Dallas streets. Three different styles of trolleys (a deck roof, a Stone and Webster design car, and a Peter Witt) are still hard at work, and so far there is not a single bus anywhere in sight. (Texas/Dallas History & Archives Division, Dallas Public Library.)

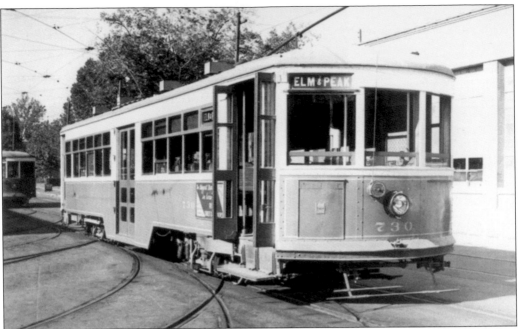

Between 1924 and 1928, Dallas Railway bought 107 modern "Peter Witt" cars. Conductors were stationed beside the center door. Passengers riding in the rear of the car paid when boarding, but riders in the front paid when getting off—an arrangement that confused many people. (Dallas Area Rapid Transit.)

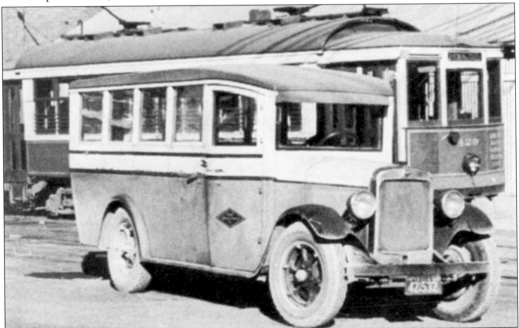

The first bus invasion into the Dallas trolley fleet consisted of seven small 18-passenger Dodge buses put in service on January 17, 1926. Although a hint of things to come, they were first only used on "feeder" lines, supplementing service on three streetcar lines. A Stone and Webster design trolley is in the background. (Dallas Area Rapid Transit.)

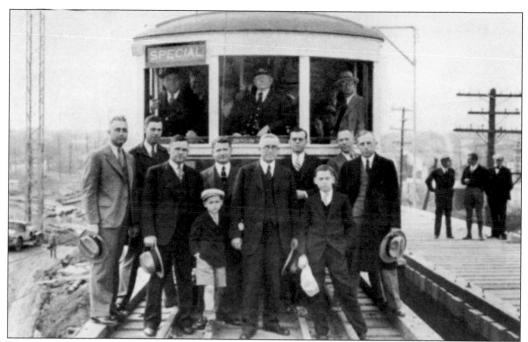

Connecting Dallas with Oak Cliff, the 1.5-mile-long, $515,000 trolley viaduct over the Trinity River was opened on February 1, 1930. A silver spike was driven to mark the completion. A large crowd gathered to watch the first car to go over the bridge, and several officials of the Dallas Railway & Terminal Company posed for the camera to mark the opening. (Dallas Area Rapid Transit.)

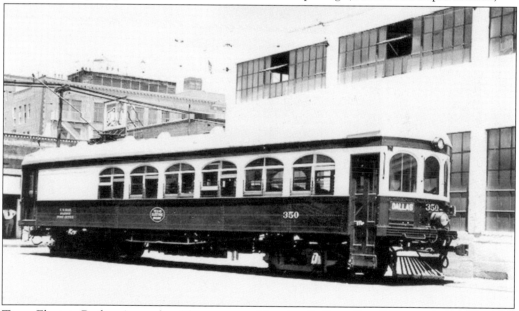

Texas Electric Railway's number 350 was a combination Railway Post Office and passenger car, running primarily between Dallas and Denison. The car is on Lane Street near Jackson Street and will soon enter the Dallas Interurban Terminal. Although its lineage is somewhat confusing due to rebuildings and renumberings, the car was most likely built in 1907. (W.C. Whittaker, Walter H. Vielbaum, McKinney Avenue Transit Collection.)

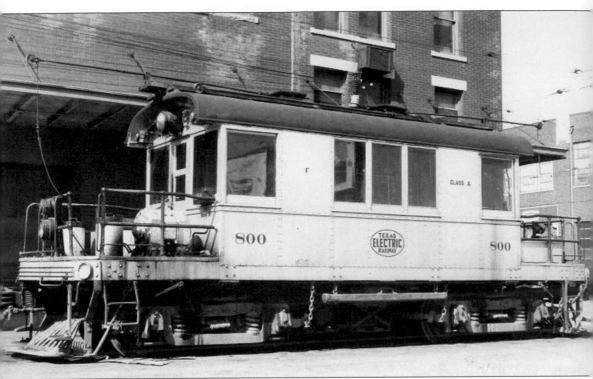

In 1928, the Texas Electric Railway began interchanging standard freight cars with the "steam railroads." Locomotives were needed to haul these cars. Number 800 was one of the first three such freight motors built in the company shops. Locomotive 800 utilized trucks and electrical equipment from passenger car 321. It was rated at 400 tons hauling capacity. (W.C. Whittaker, Walter H. Vielbaum, McKinney Avenue Transit Collection.)

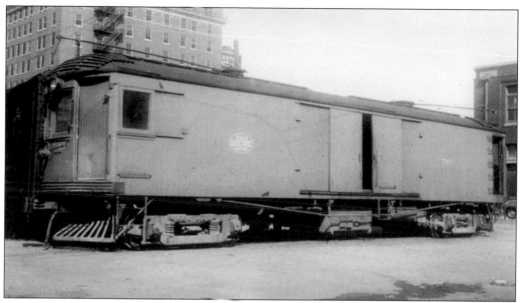

Since its beginnings, Texas Electric carried less-than-carload and express freight. Small shipments were often transported in the front of passenger cars. For larger ones, box motors, such as 503, were built for this service. The express car is at the Dallas interurban freight station. Each of these box motors could pull several express trailers or "steam road" freight cars. (W.C. Whittaker, Walter H. Vielbaum, McKinney Avenue Transit Collection.)

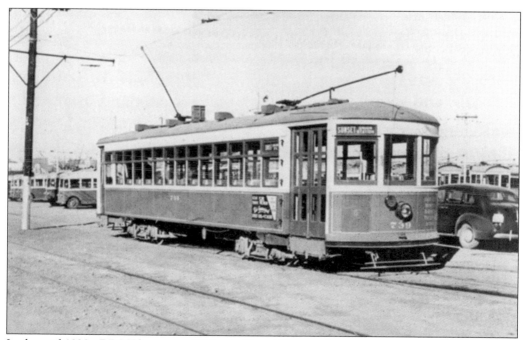

In the mid-1930s, DR&T began modifying its Peter Witt cars for one-man operation by eliminating the center doors. These cars lasted until the end of streetcar service in 1956. Rebuilt trolley 739 is in the Oak Cliff storage yard, probably posed to show off the new appearance of these cars. (Texas/Dallas History & Archives Division, Dallas Public Library.)

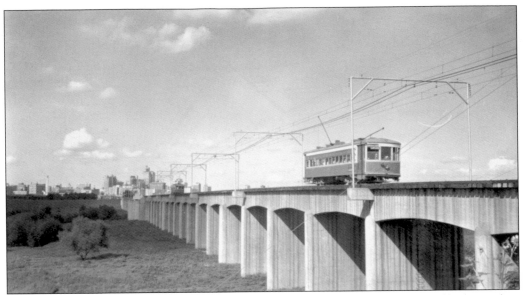

One of the rebuilt Peter Witt trolleys rolls across the viaduct en route to Oak Cliff. The viaduct saw heavy traffic. In addition to city cars, Texas Electric passenger, express, and freight trains of steam road cars going to and from Corsicana (abandoned in 1941) and Waco used the bridge. (Ohio Brass.)

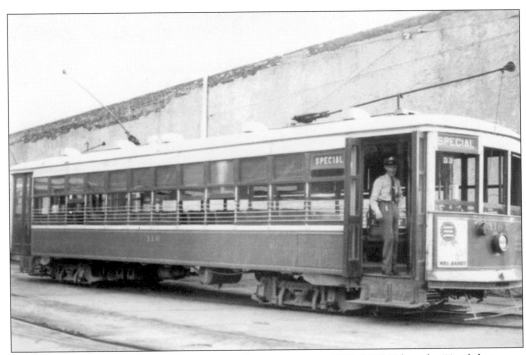

When the Texas Interurban Railway ceased operations in 1935, DR&T bought 11 of their cars and converted them to city streetcars to help handle the expected crowds that would be attending the Texas centennial at Fair Park in 1936. Numbered 111–121, these cars survived until the end of Dallas streetcar service in 1956. (Walter H. Vielbaum, McKinney Avenue Transit Collection.)

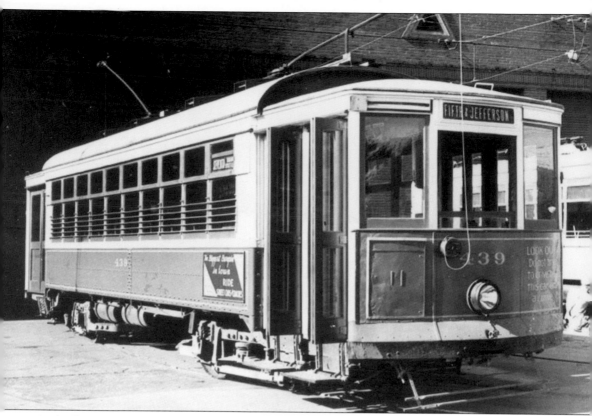

At the East Dallas shops, trolley 439 shows off its signature Stone and Webster roof design. Stone and Webster owned Dallas streetcar lines from 1902 to 1917. A total of 79 trolleys of this design were built for Dallas in 1914. One car of this group, No. 434, is preserved at the Seashore Trolley Museum in Kennebunkport, Maine. (Dallas Area Rapid Transit.)

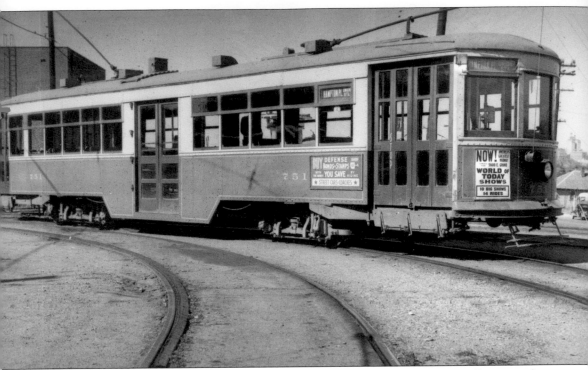

Car 751 is shown in its pre–World War II green color scheme. This cosmetically restored car, painted in the final DR&T's red and cream color scheme, is now owned by the McKinney Avenue Transit Authority. When complete it will have air-conditioning, new controllers, AC instead of DC electric motors for smoother acceleration and deceleration, a quieter ride and many other improvements. (Walter H. Vielbaum, McKinney Avenue Transit Collection.).

Two

The First Streetcar Era
Weathering the War

As the 1940s dawned, there was a growing perception that the streetcar was unattractive and obsolete and that the gasoline bus was the future of public transit. Although many cities had already started replacing their trolleys with buses, in 1942, the Office of Defense Transportation (ODT) banned the trolley-to-bus conversions for the duration of World War II. Gasoline and rubber shortages gave anything on rails a job to do. The ODT also oversaw the transfer of bus fleets to areas that were seen to be more vital to the war effort.

By the start of World War II, DR&T's extensive streetcar system was ready to cope with wartime restrictions. In addition, the Texas Electric Railway interurban trolleys were still carrying passengers and freight between Waco and Denison via Dallas.

However, the war put a huge strain on both trolleys and buses nationwide as passenger loads mushroomed. Cities with rail transit weathered the war better than those without. Dallas's trolleys were a valuable resource to keep the city mobile. To save wear and tear of their transit vehicles, DR&T eliminated about a third of the city's streetcar and bus stops by implementing a skip-stop program, where trolleys and buses only loaded and unloaded passengers at every other stop on most lines.

DR&T's Night Owl service between 1:00 a.m. and 4:45 a.m. was continued during the war for the convenience of nightshift workers at war plants. However, in 1945, the war mobilization director asked that all late-night service be pared back. The service was never profitable, but it was maintained as a gesture of good will.

Assuming that streetcars would continue be the city's primary transit vehicle, in 1941, Dallas placed an order for 25 streamlined PCC trolleys. However, wartime priorities delayed their delivery until after VE Day. The PCCs debuted to the public on June 14, 1945, less than three months before VJ Day. They were an instant hit with the riding public.

In 1944, DR&T placed an order for 24 electric trolley buses (ETBs). Dallas would be the only city in Texas to operate these "trackless trolleys."

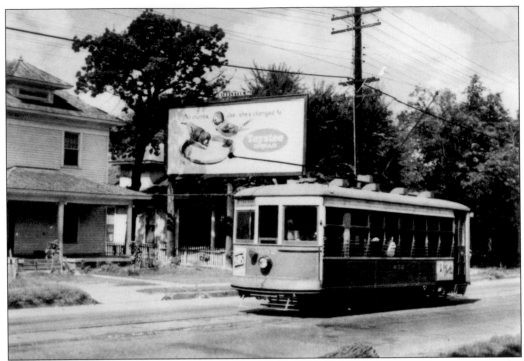

With America taking a neutral stance, the escalating war in Europe was a sharp contrast to the peaceful scene of Birney car 652, rolling peacefully on the Oak Lawn line in 1940. This line ran on McKinney Avenue from downtown to Bowen Street. It continued down Bowen to the Oak Lawn section of Dallas. (Jim Cumbie Collection.)

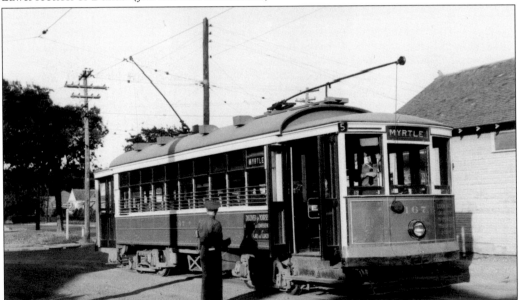

It is 1942, and America has been drawn into the war. With gas and rubber rationing starting to take effect, Dallas's extensive trolley system is proving to be a reliable transit asset during the conflict. Car 167, built in 1911, is still going strong on the Myrtle line in South Dallas. (Jim Cumbie Collection.)

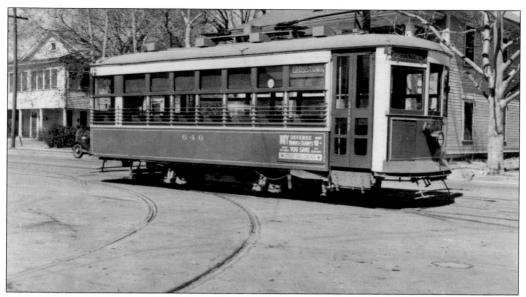

In March 1942, the advertising card on the side of this trolley says that riding public transit served the war effort: "Buy Defense Bonds and Stamps with the money you save by riding streetcars and coaches." Riders could purchase 10¢ saving stamps and collect them until enough stamps were accumulated to purchase a bond. (Jim Cumbie Collection.)

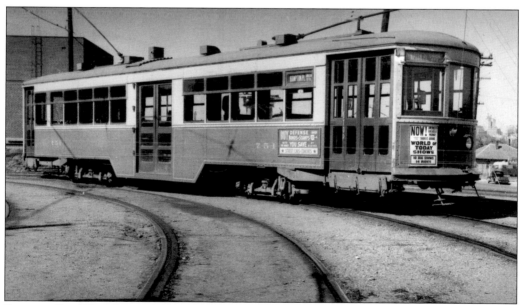

Since trolley 751 carries an advertising card identical to the one in the image above, it shows that by the early 1940s, not all of the Peter Witt cars had been converted to one-man operation. The car, signed for the Oak Cliff Hampton line, appears to be in the East Dallas shop and yard area. (Jim Cumbie Collection.)

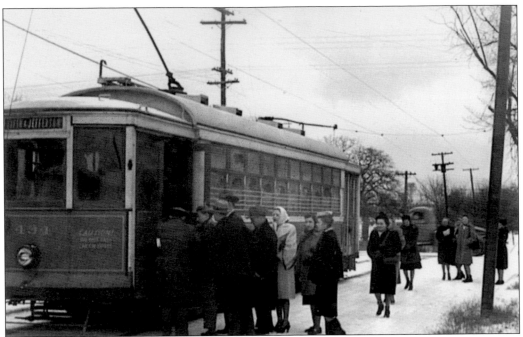

War rationing put a heavy demand on the streetcar system. In this winter scene, more than a dozen riders are trying to board trolley 434. Although often overcrowded, Dallas's streetcars provided on-time, dependable service during the war years—far superior performance compared to those cities that had abandoned their streetcar lines before the conflict. (Texas/Dallas History & Archives Division, Dallas Public Library.)

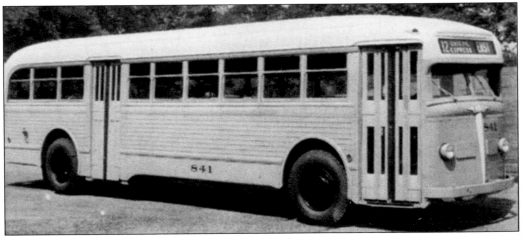

To meet the growing demands on the transit system during the war, DR&T bought 20 Office of Defense Transportation, White Company model 798 buses at a cost of $13,000 each. Although they were identical to the White buses Dallas already owned, the new ones were painted in a dull, drab gray color, as specified by the US government. (Dallas Area Rapid Transit.)

Despite the war, Downtown Dallas—the city's retail center—was still a busy place. Trolley 404, signed for Mount Auburn, is at Main and Ervay Streets. The young lady in the foreground is wearing a short skirt that was fashionable during the war to conserve material for the war effort. (Ohio Brass.)

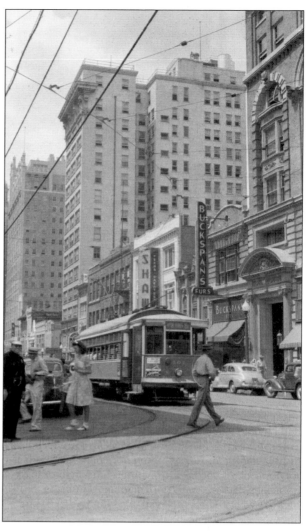

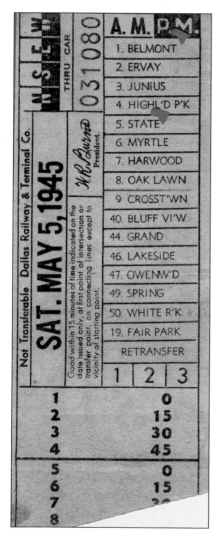

				THRU CAR		A. M.	P. M.	
	N	S	E	W	031080	1. BELMONT		
						2. ERVAY		
Not Transferable Dallas Railway & Terminal Co.						3. JUNIUS		
						4. HIGHL'D P'K		
						5. STATE		
SAT. MAY 5, 1945					President.	6. MYRTLE		
						7. HARWOOD		
						8. OAK LAWN		
						9 CROSST'WN		
	Good within 15 minutes as indicated on the date issued only, at first point of intersection or transfer point, on connecting lines except to vicinity of starting point.					40. BLUFF VI'W		
						44. GRAND		
						46. LAKESIDE		
						47. OWENW'D		
						49. SPRING		
						50. WHITE R'K		
						19. FAIR PARK		
						RETRANSFER		
						1	2	3

1	0
2	15
3	30
4	45
5	0
6	15
7	30
8	

This transfer issued by DR&T is dated just three days before VE Day. Routes 1 through 9 on this stub are streetcar lines. Each motorman had his own personal hand punch, which cut a distinctive shape on the transfer. If any problem arose with the transfers, DR&T could determine by the punched holes who the issuing motorman was. (Jim Cumbie Collection.)

During the war, anything on rails had a job to do, and the Texas Electric was no exception. Although most of its right-of-way paralleled steam railroad lines, its fast, frequent service provided a practical and welcome alternative to conventional passenger trains. Several cars about to be scrapped were rebuilt to handle the increased wartime traffic. (Jim Cumbie Collection.)

Dallas-Waco Division
TIME CARD No. 113-A

Subject to change without notice

Effective April 5, 1942

SOUTHBOUND—DALLAS TO WACO (Read Down)

STATIONS	211	213	215	217	219	221	223	225	227	229	231	233	235	237	239	511 (Baggage and Express)	
	AM	AM	AM	AM	AM	AM	PM	PM	PM	PM	PM	PM	PM	AM	PM	AM	AM
Lv. Dallas		5 30	7 30	8 30	9 30	11 30	1 30	2 30	3 30	4 30	5 30	‡6 15	7 30	9 30	11 05	12 15	§11 30
* Oak Cliff Junction		5 40	7 40	8 40	9 40	11 40	1 40	2 40	3 40	4 40	5 40	‡6 25	7 40	9 40	11 15	12 20	§11 40
* Monroe		5 49	7 49	8 49	9 49	11 49	1 49	2 49	3 49	4 49	5 49	‡6 34	7 49	9 49	11 24	12 27	§11 49
* Lisbon		5 54	7 54	8 54	9 54	11 54	1 54	2 54	3 54	4 54	5 54	‡6 39	7 54	9 54	11 30	12 32	§11 54
* Lancaster		6 07	8 07	9 07	10 07	12 07	2 07	3 07	4 07	5 07	6 07	‡6 52	8 07	10 07	11 43	12 48	§12 07
* Red Oak		6 17	8 17	9 17	10 17	12 17	2 17	3 17	4 17	5 17	6 17	‡7 06	8 17	10 17	11 53	1 00	§12 17
* Sterrett		6 22	8 22	9 22	10 22	12 22	2 22	3 22	4 22	5 22	6 22	‡7 11	8 22	10 22	11 58	1 05	§12 22
* Waxahachie		6 34	8 34	9 34	10 34	12 34	2 34	3 34	4 34	5 34	6 34	‡7 25	8 34	10 34	12 10	1 25	§12 34
* Forreston		6 48	8 48	9 48	10 48	12 48	2 48	3 48	4 48	5 48	6 48		8 48	10 48		1 42	§12 48
* Italy		6 56	8 56	9 56	10 56	12 56	2 56	3 56	4 56	5 56	6 56		8 56	10 56		2 07	§12 56
* Milford		7 06	9 06	10 06	11 06	1 06	3 06	4 06	5 06	6 06	7 06		9 06	11 06		2 25	§1 06
* Hillsboro	6 40	7 28	9 28	10 28	11 28	1 28	3 28	4 28	5 28	6 28	7 28		9 28	11 28		3 03	§1 28
* Abbott	6 56	7 44	9 44	10 44	11 44	1 44	3 44	4 44	5 44	6 44	7 44		9 44	11 44		3 25	§1 44
* West	7 06	7 53	9 53	10 53	11 53	1 53	3 53	4 53	5 53	6 53	7 53		9 53	11 53		3 40	§1 53
* Elm Mott	7 21	8 05	10 05	11 05	12 05	2 05	4 05	5 05	6 05	7 05	8 05		10 05	12 05		3 55	§2 05
Ar. Waco	7 40	8 25	10 25	11 25	12 25	2 25	4 25	5 25	6 25	7 25	8 25		10 25	12 25		4 15	§2 25
STATIONS	AM	AM	AM	AM	PM	PM	PM	PM	PM	PM	PM		PM	PM		AM	PM

NORTHBOUND—WACO TO DALLAS (Read Down)

STATIONS	210	212	214	216	218	220	222	224	226	228	230	232	234	236	238	512 (Baggage and Express)	514
	AM	AM	AM	AM	AM	AM	AM	PM	PM	PM	PM	PM	PM	PM	PM	AM	AM
Lv. Waco			6 20	7 00	8 00	9 00	11 00	1 00	2 00	3 00	4 00	5 00	‡6 00	7 00	9 00	‡10 10	6 30
* Elm Mott			5 40	7 21	8 21	9 21	11 21	1 21	2 21	3 21	4 21	5 21	‡6 21	7 21	9 21	‡10 30	6 50
* West			5 52	7 34	8 34	9 34	11 34	1 34	2 34	3 34	4 34	5 34	‡6 34	7 34	9 34	‡10 53	7 14
* Abbott			6 02	7 44	8 44	9 44	11 44	1 44	2 44	3 44	4 44	5 44	‡6 44	7 44	9 44	‡11 02	7 27
* Hillsboro			6 15	7 58	8 58	9 58	11 58	1 58	2 58	3 58	4 58	5 58	‡6 58	7 58	9 58	‡11 28	8 03
* Milford			6 34	8 17	9 17	10 17	12 17	2 17	3 17	4 17	5 17	6 17		8 17	10 17	‡11 53	8 30
* Italy			6 44	8 27	9 27	10 27	12 27	2 27	3 27	4 27	5 27	6 27		8 27	10 27	‡12 33	8 56
* Forreston			6 53	8 35	9 35	10 35	12 35	2 35	3 35	4 35	5 35	6 35		8 35	10 35	‡12 48	9 05
* Waxahachie		6 35	7 09	8 51	9 51	10 51	12 51	2 51	3 51	4 51	5 51	6 51		8 51	10 51	‡1 15	9 33
* Sterrett		6 45	7 19	9 01	10 01	11 01	1 01	3 01	4 01	5 01	6 01	7 01		9 01	11 01	‡1 27	9 44
* Red Oak		6 50	7 24	9 06	10 06	11 06	1 06	3 06	4 06	5 06	6 06	7 06		9 06	11 06	‡1 33	9 50
* Lancaster	‡6 18	7 02	7 36	9 18	10 18	11 18	1 18	3 18	4 18	5 18	6 18	7 18		9 18	11 18	‡1 47	10 07
* Lisbon	‡6 30	7 14	7 45	9 30	10 30	11 30	1 30	3 30	4 30	5 30	6 30	7 30		9 30	11 30	‡2 04	10 21
* Monroe	‡6 35	7 21	7 54	9 35	10 35	11 35	1 35	3 35	4 35	5 35	6 35	7 35		9 35	11 35	‡2 09	10 26
* Oak Cliff Junction	‡6 42	7 27	8 01	9 42	10 42	11 42	1 42	3 42	4 42	5 42	6 42	7 42		9 42	11 42	‡2 14	10 31
Ar. Dallas	‡6 55	7 40	8 15	9 55	10 55	11 55	1 55	3 55	4 55	5 55	6 55	7 55		9 55	11 55	‡2 28	10 45
STATIONS	AM	AM	AM	AM	AM	AM	PM	PM	PM	PM	PM	PM	PM	PM	PM	PM	PM

‡—Does not run on Sundays.
§—Express trailer operated on regular 11:30 A. M. Passenger Car daily, except Sunday
All trains on this division carry Baggage and Preferred Express.

In addition to civilian traffic, servicemen from the Connally Army Air Base in Waco rode the interurban to Dallas on weekend furlough trips. The railway's one mistake was abandoning its Corsicana line in 1941. An Army camp and a munitions factory there would have provided substantial traffic. (Jim Cumbie Collection.)

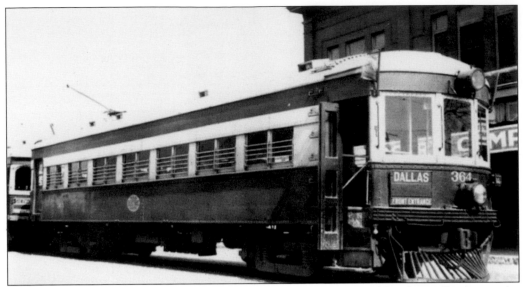

Although the Texas Electric Railway did not see much increase of freight traffic during the war, passenger revenues climbed to a net figure of over $2 million in 1945. The interurban also experienced a lively commuter business to Dallas from the north and the south. On February 24, 1945, Car 364 is in Denison about to depart on its daily run to Dallas. (W.C. Whittaker, Walter H. Vielbaum, McKinney Avenue Transit Collection.)

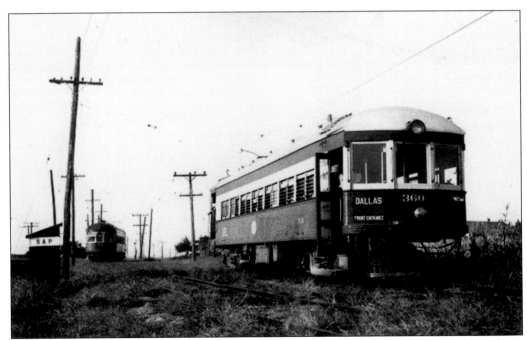

In the 1940s, Texas Electric began modernizing its cars by squaring off their arched windows. Square-windowed, Dallas-bound interurban 360 meets an arch-window car at a passing track north of Sherman known as SAP siding. Car 360 has been cosmetically restored and is now on display at the Plano Interurban Museum.

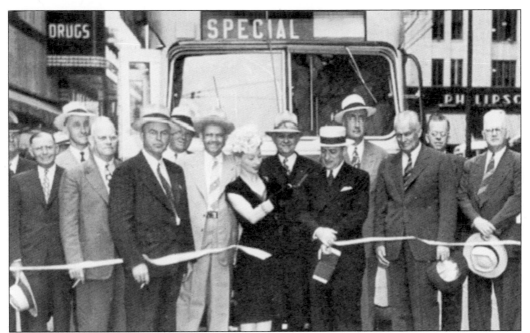

In June 1945, before VJ Day, Dallas received 25 PCC cars, whose arrival had been delayed by wartime restrictions. Surrounded by local dignitaries, Patricia Bowman, a Starlight Operetta ballerina, cuts a ceremonial ribbon to dedicate the new cars entering into service. Some 8,000 people turned out to inspect the first car before its maiden run. (Dallas Area Rapid Transit.)

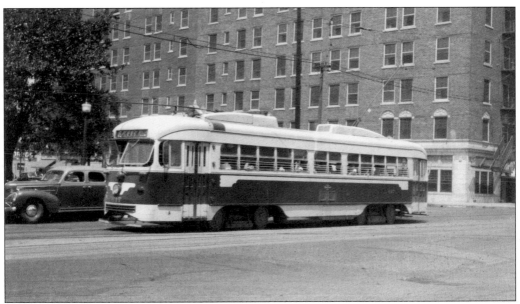

Dallas did not specify a color scheme for their new PCCs, so the builder chose to paint the trolleys red and white, with trim similar to that used by California's Pacific Electric Railway. The cars' design, performance, and colors set them apart from all of the other trolleys in the DR&T fleet. They were also unique double-ended cars. Most PCCs were single-ended cars. (Texas/Dallas History & Archives Division, Dallas Public Library.)

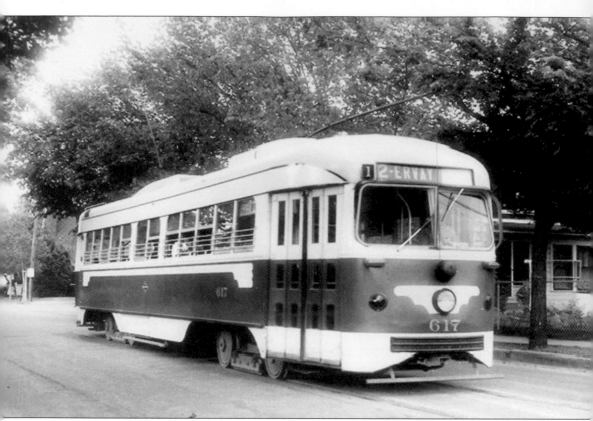

The PCC was a revolutionary streetcar, developed in the 1930s by an industry-wide cooperative research program that was led by the Electric Railway Conference Committee. The cars were of a universal design, as to be suitable for use in any city, and benefitted from the cost savings of mass production. They were smooth, quiet, fast, and comfortable. Over 4,000 were built and ran in 29 North American cities. In Dallas, they were promoted as "Gliding Beauties." The Dallas PCCs were initially put in service on the Ervay line to South Dallas and through-routed to the Seventh line in Oak Cliff. (W.C. Whittaker, Walter H. Vielbaum, McKinney Avenue Transit Collection.)

Three

THE FIRST STREETCAR ERA
THE RIDE DOWNHILL

Dallas's new electric trolley buses (ETBs) arrived in 1945 and began service on two routes. Like the PCC trolleys, they were instant crowd pleasers.

Immediately after, the war patronage and revenues soared temporarily. Soon, however, the proliferation of automobiles and free highways began to draw people away from public transit again.

DR&T had originally planned to order more PCC trolleys but instead came to regard the ETBs as "trackless PCCs" and the future of public transit. More ETBs were ordered. Streetcars gradually began to be replaced by electric or gasoline buses. A few lines went through an odd sequence of conversions, from streetcar, to motorbus, to electric trolley bus. By 1950, the number of Dallas streetcars had dropped to 121. Dallas was buying ETBs and motorbuses instead of streetcars. Also, DR&T began scrapping many of their older trolleys in the mid-1950s.

After two catastrophic head-on collisions, the Texas Electric Interurban decided to call it quits before it went bankrupt. Although all other service ended on December 31, 1948, TERy switched freight cars to and from the Oak Cliff Hormel Plant until September 10, 1949, at which time the Santa Fe Railroad completed a spur line to the plant. A ghost of the TERy remained in the form of Texas Electric Bus Lines, carrying passengers between Dallas and Waco.

In Dallas, the replacement of streetcars with buses accelerated after 1950, until by 1956, only four trolley lines out of the once extensive system remained.

The DR&T was sold in 1955 and became the Dallas Transit Company (DTC). The mayor believed that Dallas could never become a modern city while it was "tied to an antiquated electric rail transit system." Most of the trolleys were 30 years old and over, and there were no plans to extend the existing system to keep pace with the city's growth. To force the issue, the city council refused to grant the new DTC a fare increase unless the last streetcar lines were abandoned. So in 1956, the Dallas streetcars ran for the last time. Who could have imaged that they would ever return?

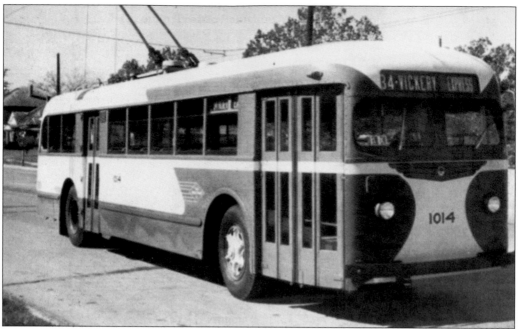

Dallas's first order of electric trolley buses (ETBs) replaced motorbuses on the Vickery and Capitol Lines in November 1945. The ETBs had the benefit of electric propulsion and much of the flexibility of a city bus. During the next 11 years, several streetcar lines would be replaced by electric trolley buses. (Dallas Area Rapid Transit.)

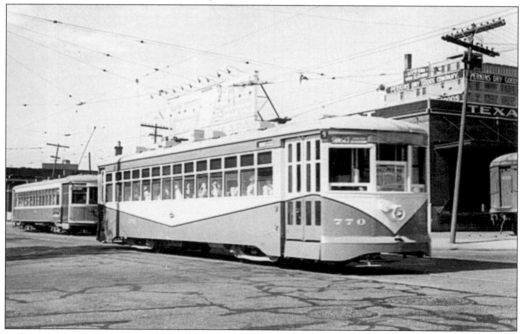

A few of the converted Peter Witt trolleys were given a makeover to give them a semi-streamlined appearance. En route to Oak Cliff, trolley 770 is on Jefferson Street passing the Texas Electric freight station. The car is painted in DR&T's first post–World War II, green-and-cream paint scheme. (Ohio Brass.)

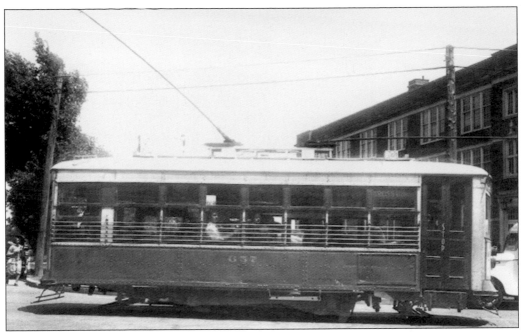

Birney 657 is at Haskell Drive and Cole Avenues, just about the northeastern boundary of today's Uptown. North Dallas High School is in the background. In 1988, the remains of this car were found in Cedar Hill in southern Dallas County, and parts from it were used in MATA's restoration of Dallas Birney car 636. (W.C. Whittaker, Walter H. Vielbaum, McKinney Avenue Transit Collection.)

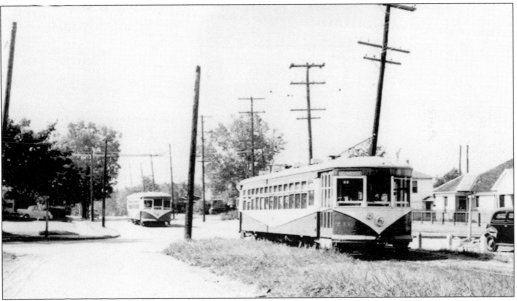

In 1948, two DR&T Belmont Route trolleys meet on tracks owned by Texas Electric Railway on Matilda Street. Although the TERy tracks continued north to Denison, this local line terminated at Mockingbird Lane. After the Texas Electric ceased operations on December 31, 1948, DR&T bought the tracks as far as Mockingbird Lane and continued running the Belmont line until March 1955. (Walter H. Vielbaum, McKinney Avenue Transit Collection.)

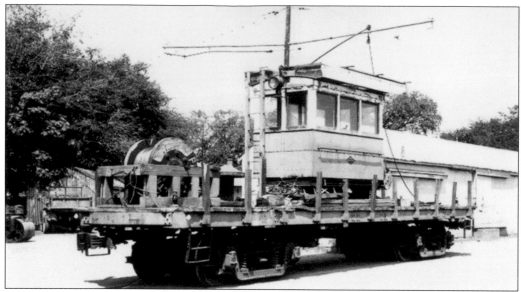

This Dallas Railway & Terminal work car was built in 1913 and served until the city's last streetcar lines were abandoned in January 1956. The car was used in maintenance of the overhead trolley wire. DR&T's post–World War II, diamond-shaped logo is visible on the side of the cab. (Walter H. Vielbaum, McKinney Avenue Transit Collection.)

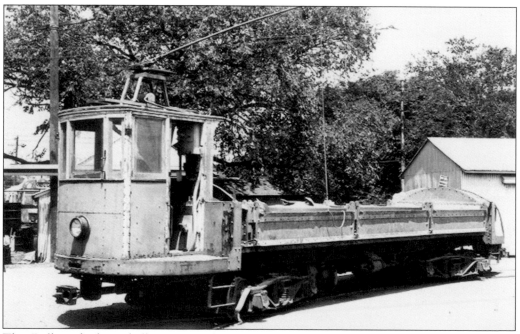

This Dallas side-dump ballast car number 508, built by the Differential Car Company in 1925, was leased to the Texas Interurban Railway from that year until 1931. DR&T finally purchased it from the interurban in 1935. This type of car was used for track maintenance. All DR&T work cars were painted green. (Walter H. Vielbaum, McKinney Avenue Transit Collection.)

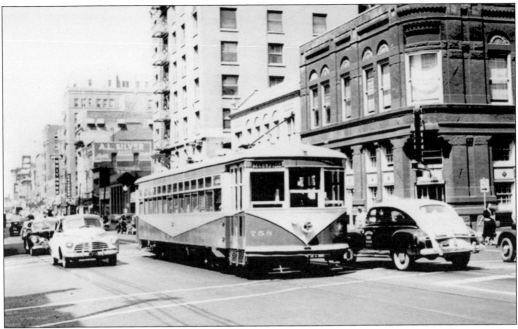

Modified Peter Witt trolley 758 is running on Commerce Street in downtown Dallas on a hot August day in 1948. As a safety measure, the passenger windows are covered with screens to prevent anyone from leaning his or her arm or head out the window and being hit by a passing streetcar. (Walter H. Vielbaum, McKinney Avenue Transit Collection.)

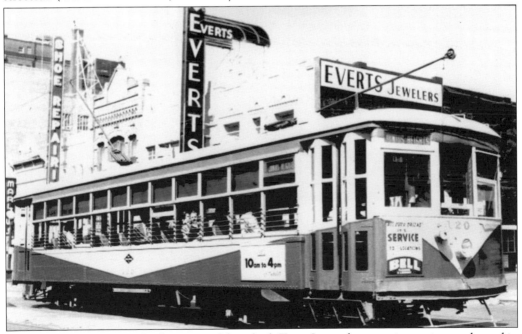

Signed for the Junius Heights line, one of the rebuilt Texas Interurban cars is running eastbound in the 1600 block of Main Street. The "10 am to 4 pm" wording on the advertising card is promoting the best times of the day to ride public transit for shopping excursions. (W.C. Whittaker, Walter H. Vielbaum, McKinney Avenue Transit Collection.)

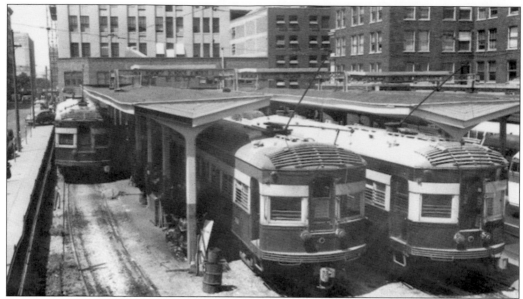

In August 1948, just five months before the Texas Electric Railway's final run, the Dallas interurban terminal was still a busy place. By this time, though, intercity buses were sharing the terminal with the big electric cars. The Trailways bus system owned the terminal from the 1950s until 1985. In 2005, the building was converted into loft apartments with retail on the first floor. (Walter H. Vielbaum, McKinney Avenue Transit Collection.)

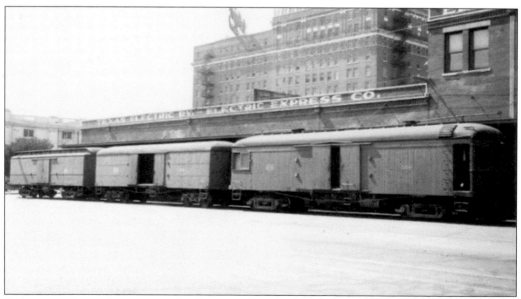

A three-car, interurban express freight train is on the Young Street side of the Dallas interurban freight station. It was common practice to run three-car express trains between Dallas and Waco. The Dallas Union (train) Station can be seen in the background. The different rooflines of the two trailer cars are also visible. (Walter H. Vielbaum, McKinney Avenue Transit Collection.)

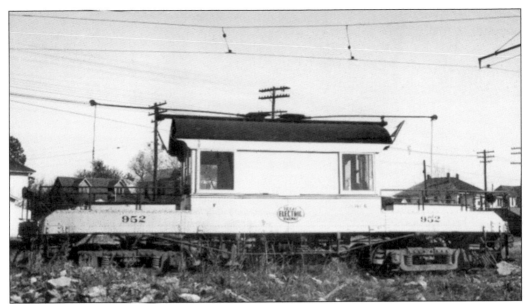

Texas Electric locomotive 952 was originally a passenger car built in 1907. TERy rebuilt it into a locomotive in 1929. In 1949, it was sold to the Texas Transportation Company in San Antonio, where the locomotive switched freight cars in and out of the Pearl Brewery until that facility closed in 2001. (C. Whittaker, Walter H. Vielbaum, McKinney Avenue Transit Collection.)

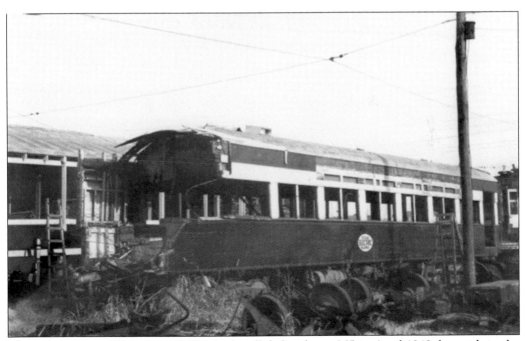

The ruins of Texas Electric car 366, which collided with car 365 in April 1948, languish in the Monroe Shops. Car 365 was rebuilt and was the last official train to leave Denison on December 31, 1948. (Walter H. Vielbaum, McKinney Avenue Transit Collection.)

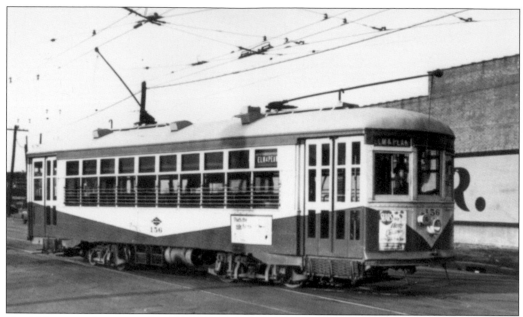

Car 156 is one of a group of trolleys built by DR&T in 1936 from former Sherman, Texas, city car bodies and Texas Interurban Railway express car trucks. The rebuilding hid the characteristic Stone and Webster turtleback roof and gave the cars a neat, but high-roof appearance. In 1949, the car is at the East Dallas yards and shops. The twin trolley bus overhead wires are very much in evidence. (Dallas Area Rapid Transit.)

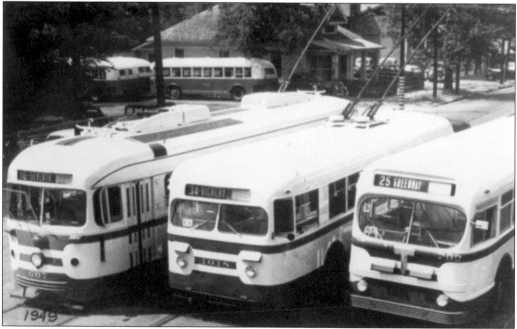

In 1949, DR&T lined up examples of its three types of modern transit vehicles beside the East Dallas yard for a publicity photograph. The vehicles show off the company's final postwar red-and-cream color scheme. The East Dallas yard was the home base to the electric trolley buses until their demise in 1966. (Dallas Area Rapid Transit.)

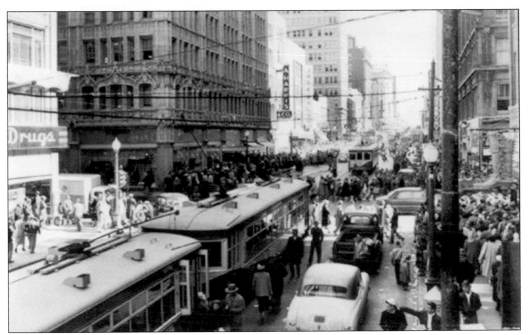

In 1950, downtown Dallas was still the site of department stores, first-class movie theaters, and many other attractions. Even though this photograph may have been taken during a special event, it would still be unlikely to see this much downtown pedestrian traffic in 2011. (Texas/Dallas History & Archives Division, Dallas Public Library.)

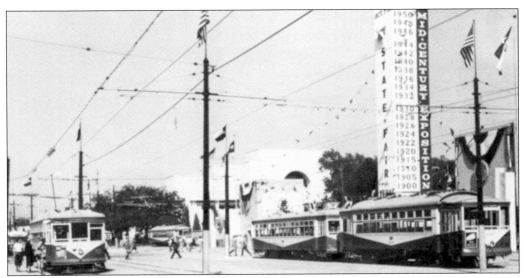

The theme of the annual 1950 Texas State Fair was a mid-century exposition. Trolleys were out in force, bringing large crowds of people to the big event. Although by 1956, ETBs still ran to Fair Park's main gate, the one remaining streetcar line to the fairgrounds only served the south-side gate and not the main entrance. (Dallas Area Rapid Transit.)

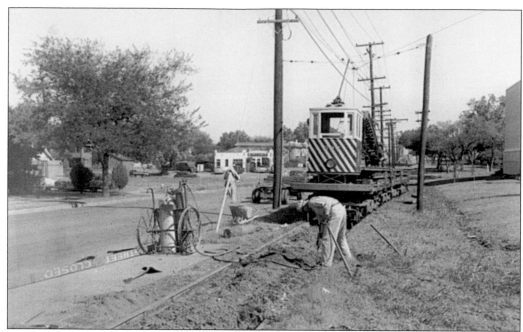

When the Highland Park trolley line was cut back to Cole Avenue and Knox Street in 1951, the tracks on the private right-of-way alongside Hillcrest Avenue and the SMU campus were removed. Here, near the intersection with Mockingbird Lane, the workman seems to be clearing soil from around the tracks so the crane car can lift the rails and put them on the flatcar it is pulling. The truck parked beside the curb appears to be loading crossties. (Texas/Dallas History & Archives Division, Dallas Public Library.)

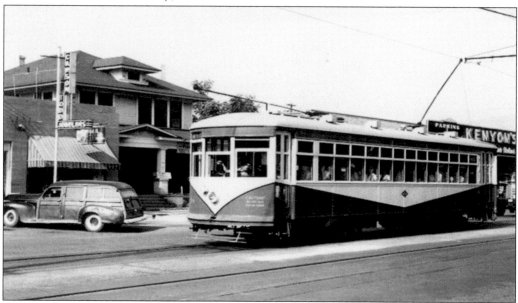

By the mid-1950s, only a few low-numbered, 100-series trolleys, the Peter Witt cars, and the new PCCs comprised the survivors of the once extensive Dallas streetcar fleet. Not all streetcars were painted in the red and cream colors. This 700-series car is running on Jefferson Street, "the Main Street of Oak Cliff." (Walter H. Vielbaum, McKinney Avenue Transit Collection.)

In 1952, in anticipation of their sale to a Mexican company, 32 of the 400-series cars were moved to the East Dallas shops to be overhauled, but the sale never materialized. The high-numbered, 100-series cars and the 300-series cars had already been scrapped. The 400-series cars were moved back to the Oak Cliff yards and stored there before they also were scrapped. (Walter H. Vielbaum, McKinney Avenue Transit Collection.)

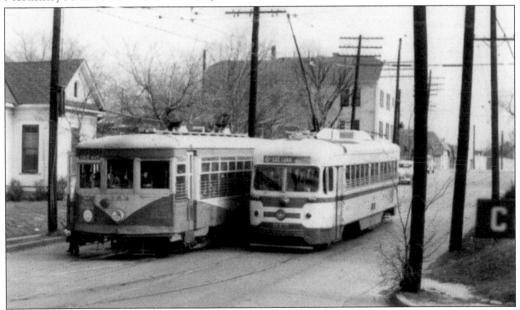

An Oak Lawn and a Cole Avenue trolley meet at Cole Avenue and Bowen Street, about a block and a half from MATA's current carbarn. The PCCs replaced Birney cars on the Oak Lawn line. As older trolleys were retired and streetcar lines replaced by buses, the PCCs were assigned to most of the remaining lines. (Courtesy of Johnnie J. Meyers.)

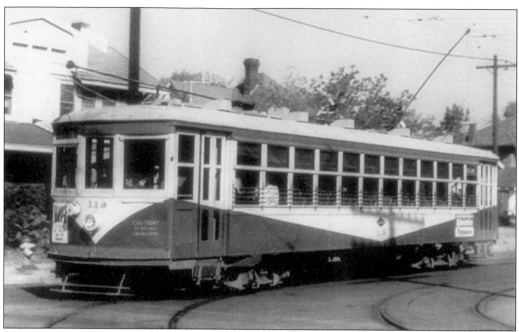

Wearing its first postwar green and cream colors, venerable old trolley 119 is at Cole Avenue and Bowen Street in 1953, probably running on the Cole Avenue line (formerly Highland Park). Time was quickly running out for this trolley line, but MATA's trolleys still would be passing through this same intersection 36 years later. (Courtesy of Johnnie J. Meyers.)

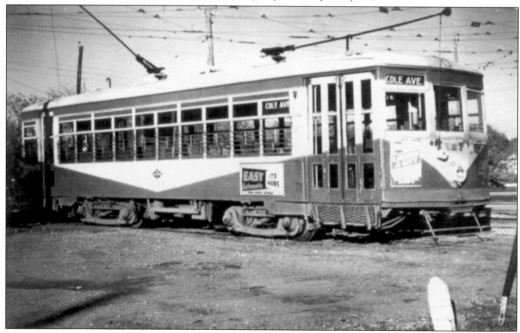

A trolley signed for the Cole Avenue line awaits departure from the East Dallas shops. Buses replaced both the Cole and Oak Lawn Lines in December 1953. Fortunately for MATA, because it was too expensive to remove the tracks from McKinney Avenue, they were left in place and simply paved over. (Dallas Area Rapid Transit.)

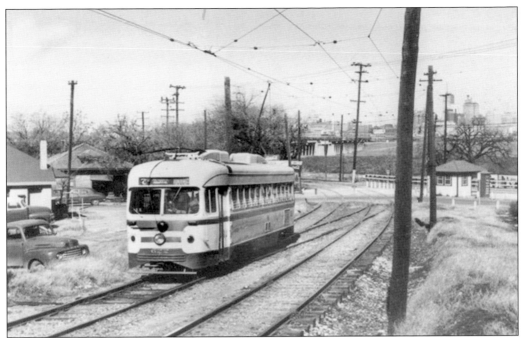

PCC 622 has just come off the viaduct, passed Oak Cliff Junction, and is running through a short stretch of private right-of-way close to the Oak Cliff yards and shops. The car is signed for route 26 (Seventh) and will soon be on city streets. The Seventh line was abandoned in March 1955. (Texas/Dallas History & Archives Division, Dallas Public Library.)

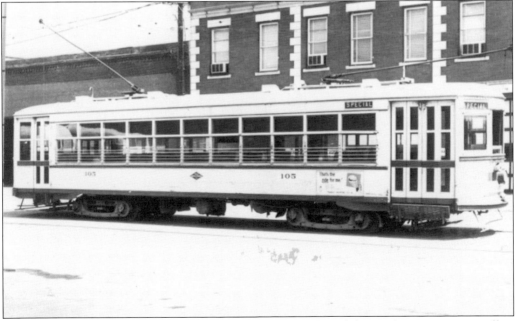

Car 105, built by DR&T in 1926 to test the effectiveness of quick herringbone gears, was still in service in postwar Dallas. Herringbone gears have the advantage of transferring power smoothly as multiple gear teeth engage and disengage simultaneously. As far as is known, this was the only Dallas trolley outfitted with these types of gears. (Dallas Area Rapid Transit.)

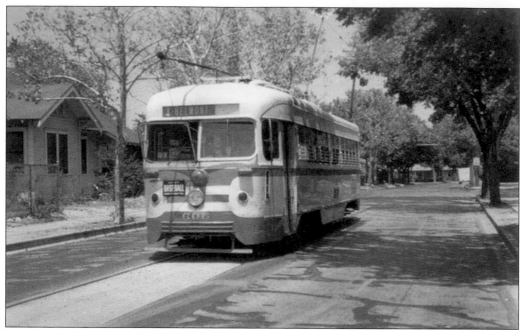

PCC 606, at the end of the Belmont line, prepares for a return trip downtown in 1954. The sign on the front reminds everyone that there is baseball tonight at the Oak Cliff ballpark, which was served by the trolley lines. Trolleys last ran on this line in March 1955. (Allan Berner Estate.)

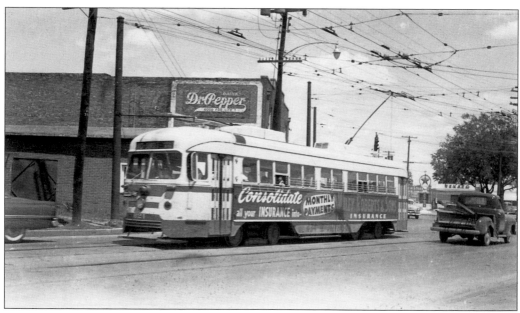

Under a canopy of trolley bus wires, PCC 621 is en route to Fair Park in June 1955. The streetcar is signed for the Sunset Line—a route appropriately named as a DR&T streetcar will make its last run on that line in January 1956 to end all streetcar service in Dallas. (Walter H. Vielbaum, McKinney Avenue Transit Collection.)

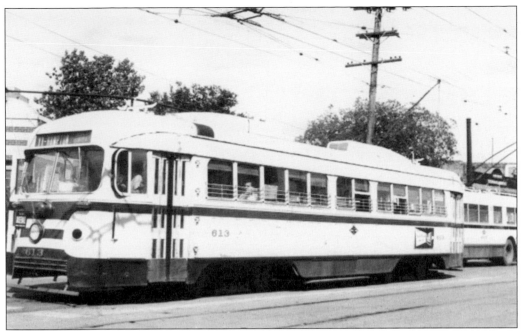

In what might be seen as an omen, PCC 613, signed for the Hampton line in Oak Cliff, is closely followed by one of its biggest competitors—an electric trolley bus. This scene is east of the Trinity River, as no trolley bus lines served Oak Cliff. The Hampton streetcar lasted until all streetcars were retired in 1956. (W.C. Whittaker, Walter H. Vielbaum, McKinney Avenue Transit Collection.)

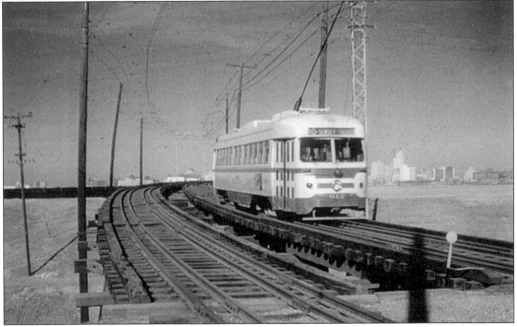

Abandonment of the last four streetcar lines (Junius, Hampton, Second, and Sunset) is just a few days away, as PCC 612 enters the Trinity River viaduct en route to Downtown Dallas. A local newspaper wrote that after 83 years of street railways in Dallas, "there will be a strange stillness"—no more rumble of their wheels or the sound of their bells. (J.R. Cumbie, Jim Cumbie Collection.)

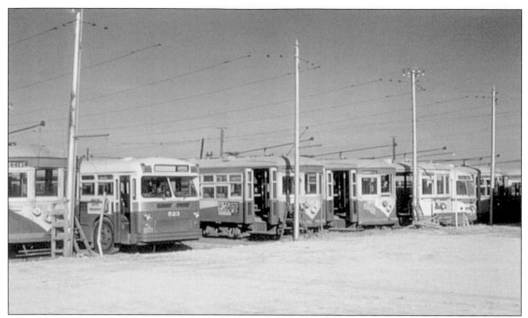

In 1956, the Oak Cliff storage yard is full of trolleys. Many of them were never painted in DR&T's red and cream colors. After system abandonment, most of the Dallas streetcars would be scrapped, except for the relatively new PCCs, which Boston bought and put in service there for 20 more years. (J.R. Cumbie, Jim Cumbie Collection.)

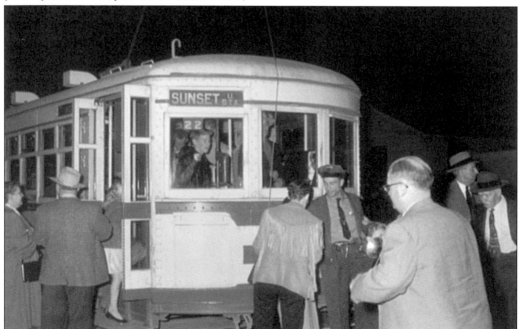

It is past midnight, and the last trolley on the Sunset line is about to return to the East Dallas shops. The passengers have gotten off the car for one more look at it and to get their souvenir transfers autographed by the operator. When this car pulls into the barn at 2:08 a.m., regularly scheduled streetcar service will officially end in Dallas, after 83 years. (J.R. Cumbie, Jim Cumbie Collection.)

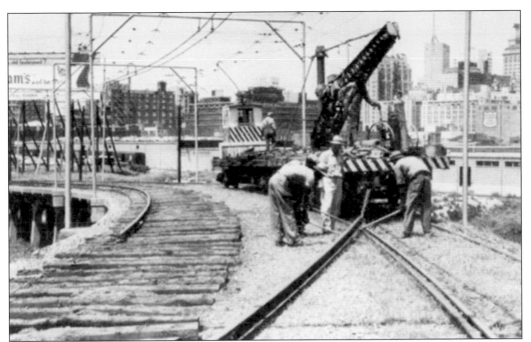

In April 1956, work began on removing tracks and wire from the viaduct. Some of the wires and poles were kept for the electric trolley bus system, but tracks and whatever else could be salvaged were sold for scrap. The viaduct stood unused until the late 1970s, when it was demolished to make way for a new Jefferson Avenue bridge over the Trinity River. (Dallas Area Rapid Transit.)

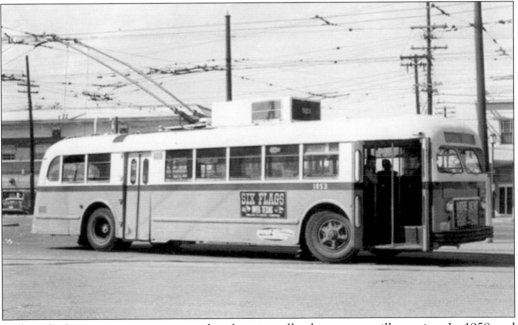

Although the streetcars were gone, the electric trolley buses were still running. In 1958 and 1959, the majority of them were even air-conditioned. AFC-Brill-built ETB 1053 is in a private transit-way on Parry Street in front of the state fairgrounds. Streetcar tracks remained in place there until Parry Street was widened in 1961. (Ohio Brass, Strayhorn Library, IRM.)

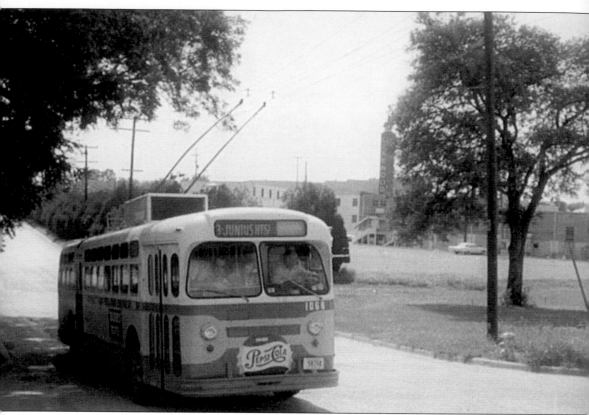

Curiously, the Junius Heights streetcar line, abandoned in 1956, was converted to electric trolley bus in 1958. One of the large coaches built by Marmon-Herrington is near the end of that line in 1964 in service and in time. Two years later, without any ceremony or much public notice, the electric transit era ended when all of the last ETB runs occurred in the wee small hours of July 28, 1966. A total of 45 Dallas ETBs were sold to Mexico City. The rest were scrapped.

Four

STATE-THOMAS
THE ROOTS OF UPTOWN, 1868

From 1868 until today, State-Thomas by any of its names has been a happening place, a place of energy and innovation, a place that draws people and new ideas. It has been the home of pioneers, civil rights pathfinders, mavericks, and problem-solvers, a stopping place for the greats of entertainment and leaders of the country.

Today, State-Thomas is 96 acres. The 23-acre State-Thomas Historic District contains the most intact collection of late 1880s Victorian structures in Dallas; the last remnant of a larger affluent community, begun as Thomas-Colby District, outside the city limits next to the newly freed slaves' Freedman's Town.

In 1868, Col. James Thomas and Elizabeth Routh Thomas settled on a 40-acre farm east of McKinney Road, north of Pearl Street. James was a prosperous businessman and a major investor in the first iron bridge crossing the Trinity River. After his death in 1875, his family continued his ventures, and the Thomas Brothers Real Estate Company created the district.

In 1869, John Wesley and Agnes Bast Overand bought 11 acres along Routh and Boll Streets, east of McKinney Road. Other additions followed.

From 1868 to 1905, horses, wagons, and carriages traveled unpaved neighborhood streets. Front yards had hitching posts, and Thomas Avenue was a path for cattle drives to Max Hahn's Packinghouse, located downtown on Alamo Street. The scenic Dallas Branch Creek meandered through the area under wooden bridges at Colby and Routh Streets and Thomas Avenue near Boll Street. Abundant wildlife and nearby cemeteries—Greenwood, Calvary, Temple Emanu-El, and Freedman's—gave the neighborhood a rural character.

The community was first served by mule-drawn trolleys and then by the steam-powered Dallas Circuit Street Railway by 1887. After 1903, a second electric streetcar line operated on a loop along State Street to downtown and the state fairgrounds in East Dallas, an advantage to the residents.

After 1910, the elite families began moving to more fashionable neighborhoods like Highland Park, Munger Place, or Swiss Avenue. Thomas-Colby began to fade.

By the 1930s, many African Americans of Freedman's Town, becoming known as "North Dallas," were now able to purchase or rent the larger homes.

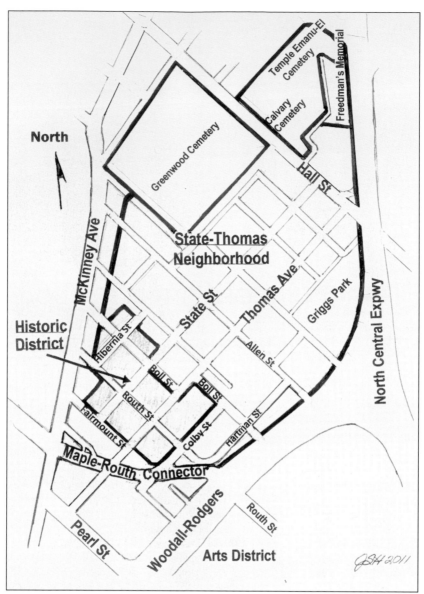

This map shows today's 96-acre master planned State-Thomas Neighborhood. A number of historic homes have been preserved inside the 23-acre State-Thomas Historic District. Adjacent are four historic cemeteries: Greenwood (established 1874), Calvary (established 1878), Temple Emanu-El (established 1884), and Freedman's Memorial, which was dedicated 1999 on the site of an 1850s slave burial ground, much of which was insensitively destroyed by the construction of North Central Expressway. Freedman's Town unofficially began here after emancipation, as ex-slaves came seeking jobs in the city and on the coming railroad, settling around familiar burial grounds of their ancestors. There was safety in numbers and in living outside the city limits. A few sympathetic whites sold them land to build small houses. By 1879, ex-slaves owned 15.5 acres in Freedman's. Simultaneously, the Thomas Brothers were building the affluent Thomas-Colby District blocks away. The businessmen and their families in Thomas-Colby provided jobs for freedmen in their homes or businesses downtown. The two neighborhoods existed and grew side by side from the beginning. (Map by Judy Smith Hearst.)

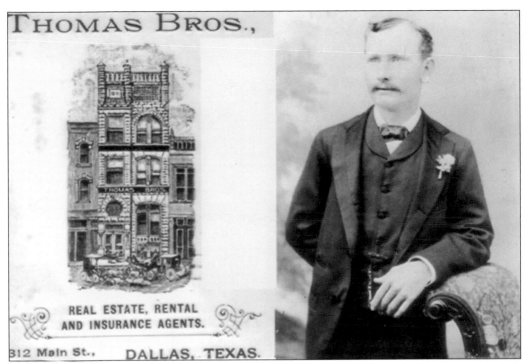

THOMAS BROS.,

REAL ESTATE, RENTAL
AND INSURANCE AGENTS.

312 Main St., DALLAS, TEXAS.

Jefferson D. Thomas was the son of original residents Col. James and Elizabeth Thomas. In 1883, Jefferson D. and brothers Oliver and Colby Thomas founded the Thomas Brothers Real Estate Company and platted the Thomas Addition to begin the first development, the Thomas-Colby District, advertised as "North Dallas, high ground that was healthful, cooler and less muddy" than the city. (Uptown Dallas Inc. Archives.)

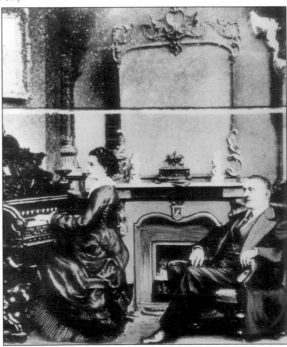

French immigrant Maxime Guillot appears with his daughter May in 1876. With experience as an Army wagon master, he came to Dallas in the 1850s to establish the first factory, a wagon and carriage manufacturing business on Elm Street at Record. Guillot was also a translator for the La Reunion colonists. He sold 95 acres of his farm in the neighborhood to Col. James Simpson in 1887. (Uptown Dallas Inc. Archives.)

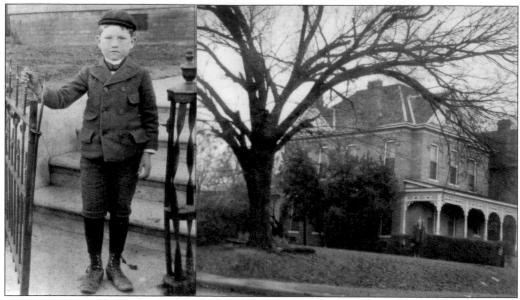

Dallas Morning News publisher George Bannerman Dealey's home (pictured on the right) was 195 Thomas Avenue (now 2605) until 1901. Dealey rode the streetcar to downtown. Pictured on the left, Dealey's son Ted remembers the delivery of the neighborhood's first bathtub, which was to be installed in their home on Thomas Avenue, drawing crowds of curious residents, becoming the talk of the neighborhood. Sadly, the home was later demolished. (Left, Uptown Dallas Inc. Archives; right, Dallas Historical Society.)

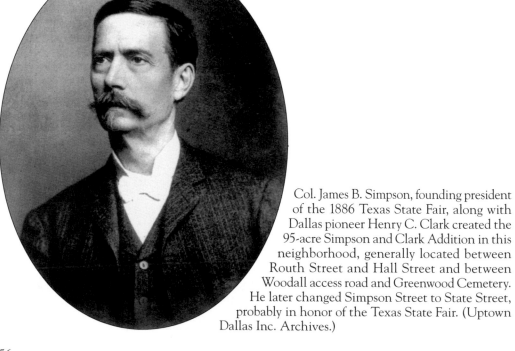

Col. James B. Simpson, founding president of the 1886 Texas State Fair, along with Dallas pioneer Henry C. Clark created the 95-acre Simpson and Clark Addition in this neighborhood, generally located between Routh Street and Hall Street and between Woodall access road and Greenwood Cemetery. He later changed Simpson Street to State Street, probably in honor of the Texas State Fair. (Uptown Dallas Inc. Archives.)

Mr. and Mrs. Simon David are pictured here vacationing in Colorado. Simon and Son Grocers opened in 1889 at the corner of Leonard and Colby Streets. They began delivery to the wealthy residents like Dealey. They were the first grocer to offer imported specialties and out-of-season items. Later, they moved the business to Oak Lawn and became the well-known Simon David's. (Texas/Dallas History & Archives Division, Dallas Public Library.)

In 1886, Agnes Overand and her carpenter stepson Edward subdivided the Overand Addition and began building stately homes—like this gracious Italianate, still at 2600 State Street, built in 1890 for Edward's daughter Eliza and her husband, Jacob Spake. The city water supply was unreliable outside city limits, so Overand dug water wells and built cisterns for most of the families in the neighborhood throughout the 1890s. (Judy Smith Hearst.)

Griggs Park namesake, former slave Allen R. Griggs, DD (1850–1922), was a dynamic minister and entrepreneur. He spent his life as an inspirational leader, stressing the importance of education and hope to African Americans. In the early 1870s, he received his first pastorate at New Hope Baptist Church on Hall Street; was trustee for the land purchase of 15.5 acres by former slaves in April 1879 in Freedman's Town; established Texas' first black newspaper, the *Baptist Pilot*; raised funds to start Bishop College; cofounded North Texas Baptist College; is credited with starting an early high school; and lived at 1728 Hall Street. Both New Hope Baptist Church and St. Paul Church (pictured below) were instrumental in creating early schools for African Americans. St. Paul Church has played a significant role in the community from its first meeting in a brush arbor in 1869 to its beautifully restored building in today's Arts District (pictured here). Built a few bricks at a time over many years, the church was completed in 1923. (Above, Baptist General Convention of Texas; below, Judy Smith Hearst.)

Five

STATE-THOMAS
AFRICAN AMERICAN "NORTH DALLAS"

Freedman's Town began about the same time in 1869 at the north end of State-Thomas near Hall Street. After emancipation, freed slaves came to the city seeking work and gathered around the old slave burial grounds, now Freedman's Memorial. It became North Dallas Freedman's Town. Sam Eakins and a group of ex-slaves bought one acre of their ancestors' burial grounds on April 29, 1869, for $25. In 1872, ex-slave William Adam bought 13 acres and ex-slave Lewis Moore bought 2 acres near Hall Street. Ex-slave Allen R. Griggs, the namesake of Griggs Park, appeared as one of the trustees on an 1872 purchase of land around Freedman's Cemetery.

The population of Freedman's Town grew with abundant railroad jobs nearby and later, with jobs in Downtown and East Dallas—thanks to streetcar access. By the 1930s, North Dallas, as it was called, had become a thriving middle-class African American neighborhood with the State Theater, the Dunbar Branch Library, dentists, attorneys, funeral homes, grocers, musicians, doctors, hotels, churches, schools, cafés, teachers, liquor stores, barbershops, and beauty parlors. The work of Griggs, New Hope Baptist, and St. Paul Churches, and many others had begun to pay off, and African Americans had access to education and professional careers.

The vibrant, mixed-use neighborhood had occurred over time out of the necessity that invented it and spilled over its boundaries, merging into the larger homes left behind by whites moving to newer neighborhoods. Many African Americans prospered in the heyday from the 1920s into the 1960s.

But change began when the area was dissected by the construction of Central Expressway and again by Woodall Rogers Freeway. Many professional African Americans sought nicer neighborhoods in South Dallas or Oak Cliff.

By 1975, owner occupancy fell to an overall low of 19 percent. Absentee landlords allowed properties to decline. The once vibrant, beautiful neighborhood lost residents, hallowed cemetery land, churches, and businesses with the drastic changes. Many buildings were demolished. Some burned.

A 23-acre cluster of homeowners and a few white urban pioneers remained with a desire to stay and fight to preserve and improve a portion of the once-proud neighborhood. Their area would become the State-Thomas Historic District.

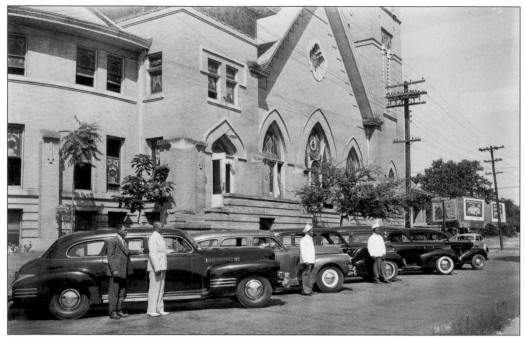

Many businesses flourished in State-Thomas's "North Dallas," including Lott's Funeral Home (pictured here in 1947), State Cab, the famous State Theater, Wright's Service Station (the first one that was African American–owned), Pinkston Clinic, Powell Hotel, Papa Dad's BBQ, Clark's Liquor and Drugs, and many others. (Texas/Dallas History & Archives Division, Dallas Public Library.)

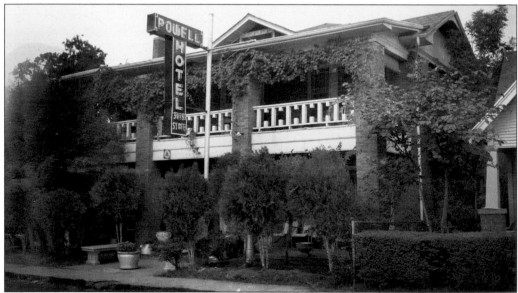

Powell Hotel at 3115 State Street (pictured here in 1946) was the first African American–owned hotel in Dallas. Among the many famous guests at Powell during its heyday in the 1930s and 1940s were composer Duke Ellington, boxer Jou Louis, jazz pianist Thomas "Fats" Waller, Southern University president Felton Clark, and trumpeter Louis Armstrong. The hotel closed in 1970 and burned down in 1975. (Texas/Dallas History & Archives Division, Dallas Public Library.)

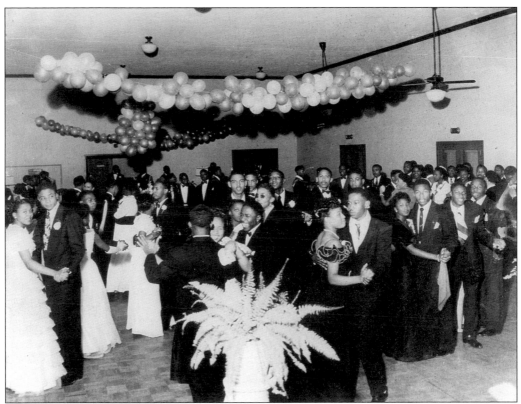

The 1946 image above was taken at Booker T. Washington High School prom night, held at the new Roseland Homes Recreation Center. The high school opened in 1892 as Dallas Colored High School, was renamed in 1922, and became a vital force for the Dallas area. The image below features neighbor J.L. Patton Jr. (center) presiding at the 1949 graduation program. Patton, principal from 1939 to 1969, positively influenced thousands of students and significantly impacted education for African Americans. He taught his students that economic emancipation came through education and job choice. He emphasized self-esteem and the phenomenal advancements made by African Americans in the short time since 1865. His concern for students extended outside the classroom; Joe Kirven recalls that Patton opened an ice cream parlor at Thomas and Clark to give students a safe, healthy place to meet and socialize. (Photographs courtesy of Joe Kirven.)

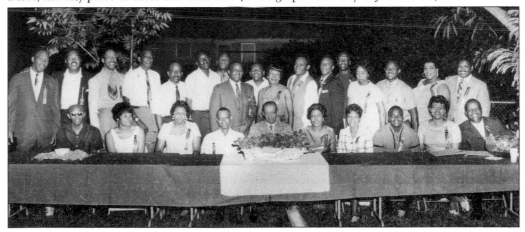

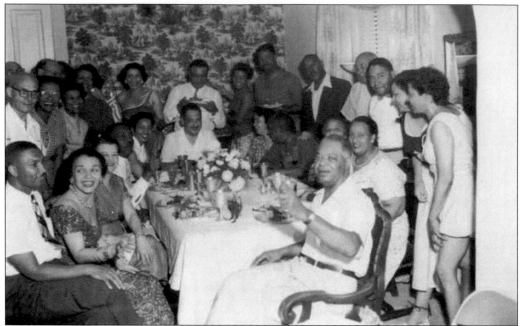

Civil rights pioneer A. Maceo Smith (foreground) sits around an elegant table in his stately home at 2407 Thomas Avenue (pictured below), at a reception for soon-to-be Supreme Court justice Thurgood Marshall (head of the table) in 1954. The celebration followed Marshall's victory in the landmark case *Brown v. Board of Education*. Referred to as "Mr. Civil Rights of Texas," Smith had a bachelor of arts degree from Fisk University, a master's in business administration from New York University, owned a New York City advertising agency, was the first editor of the weekly *Dallas Express*, the first executive secretary of Dallas Negro Chamber, a longtime NAACP activist and board member, played a prominent role in the peaceful integration of Dallas schools, and retired as assistant regional administrator of US Housing and Urban Development. He is pictured throughout Dallas history with prominent national leaders. (Above, Texas/Dallas History & Archives Division, Dallas Public Library; below, photograph by Judy Smith Hearst, 1976.)

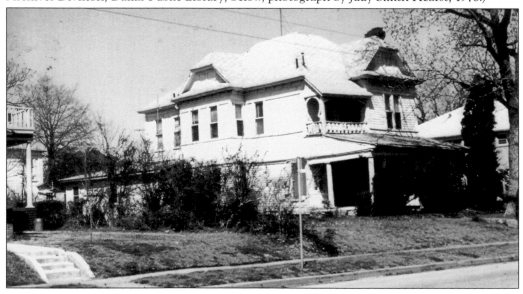

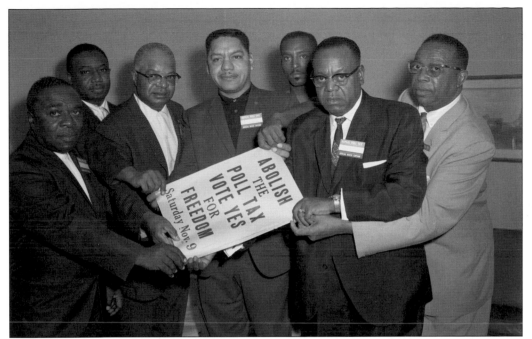

From left to right are Walter R. McMillan, Roosevelt Johnson, A. Maceo Smith, Pancho Medrano, Harold E. Holly, Rev. G.T. Thomas, and R.R. Revis, fighting against the poll tax in 1963. "Abolish the Poll Tax; Vote Yes for Freedom; Saturday, Nov. 9." Medrano was the father of Dallas City Council members Ricardo Medrano and Pauline Medrano. (Texas/Dallas History & Archives Division, Dallas Public Library.)

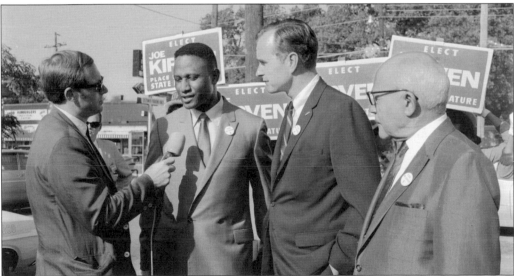

Joe Kirven, State-Thomas neighbor, was supported by future president George H.W. Bush in Kirven's 1968 campaign for state representative, place 9. Kirven became the first African American since Reconstruction to serve on a governor's staff. Gov. Bill Clements appointed Joe to handle equal opportunity and small business programs. Another successful classmate of Joe's, Robert Prince, became a doctor and, later, author of *Dallas from a Different Perspective*. (Texas/Dallas History & Archives Division, Dallas Public Library.)

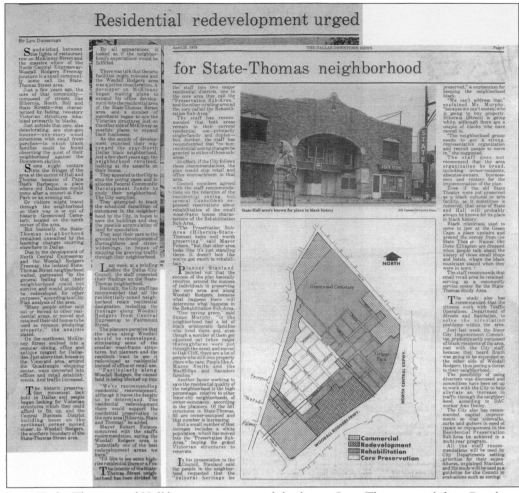

Residential redevelopment urged

By Lyn Dunsavage

April 23, 1979　　　THE DALLAS DOWNTOWN NEWS　　　Page 9

for State-Thomas neighborhood

Sandwiched between the lights of restaurant row on McKinney Street and the massive elbow of the North Central Expressway-Woodall Rodgers Freeway juncture is a small community some call the State-Thomas Street area.

Just a few years ago, the core of that community—composed of streets like Hibernia, Routh, Boll and State Streets—was characterized by fading, two-story Victorian structures inhabited primarily by blacks.

Just outside that core, also deteriorating, are shot-gun houses—one-story wood structures with small front porches—in which black families could be found observing the quiet of their neighborhood against the Downtown skyline.

Some might venture into the fringes of the area at the corner of Hall and Thomas because of Papa Dad's Barbeque, a place where old Dallasites would come after a concert at Fair Park or an evening out.

Or visitors might travel through the neighborhood on their way in or out of historic Greenwood Cemetery, located on the north corner of the area.

But basically, the State-Thomas neighborhood remained unscathed by the booming changes occurring elsewhere in Dallas.

Due to the development of North Central Expressway and the Woodall Rodgers Freeway, the isolated State-Thomas Street neighborhood waited, permeated "by the general feeling that their neighborhood could not survive and would probably be redeveloped for other purposes," according to a City Plan analysis of the area.

"Many people either sold out or moved to other residential areas, or moved and retained their old homes to be used as revenue producing property," the analysis stated.

On the northwest, McKinney Street evolved into a popular dining, office and antique magnet for Dallasites. Just above that, houses in the Vineyard area, around the Quadrangle shopping center, were converted into offices and retail establishments. And traffic increased.

The historic preservation movement took hold in Dallas and people began looking for Victorian structures which they could afford to fix up, and the Central Business District building boom on the northeast corner moved closer to Woodall Rodgers, the southern boundary of the State-Thomas Street area.

By all appearances, it looked as if the neighborhood's expectations would be fulfilled.

There was talk that the arts facilities might relocate and the Woodall Rodgers area was a prime consideration. A developer on McKinney began making plans to expand his office development into the residential area of the State-Thomas Street area, and a number of merchants began to eye the Victorian structures just on the other side of McKinney as possible places to expand their businesses.

As the sounds of development crunched their way toward the near-North Dallas black neighborhood, just a few short years ago the neighborhood revitalized, balking at the assaults on their homes.

They appealed to the City to stop the zoning cases and to allocate Federal Community Development funds to study their neighborhood. The City complied.

They attempted to track the scheduled demolition of structures in the neighborhood by the City, in hopes to save the buildings and stop the possible accumulation of land for speculation.

They kept their ears to the ground on the development of thoroughfares and street-widenings, in hopes of stopping the growing traffic through their neighborhood.

Last week, at a briefing before the Dallas City Council, the staff presented their findings on the State-Thomas neighborhood.

Basically, the City staff has recommended that all the residentially-zoned neighborhood retain residential designation, including the frontage along Woodall Rodgers from Central Expressway to Fairmount Street.

The planners perceive that the area along Woodall should be redeveloped, eliminating some of the smaller wood-frame structures, but planners and the residents want to see it redeveloped as residential instead of office and retail use.

"Particularly along Woodall Rodgers, the vacant land is being blocked up into

"We're recommending residential redevelopment, although it leaves the density to be determined. The residential redevelopment there would support the residential preservation in the core area (Hibernia, State and Thomas)," he added.

Mayor Robert Folsom concurred with the staff's recommendation, saying the Woodall Rodgers area is "potentially one of the best redevelopment areas we have."

"I'd like to see some high-rise residential there or a Fox

The interior of the State-Thomas Street neighborhood has been divided by

the staff into two major residential districts, one in the core area they call the "Preservation Sub-Area," and the other winding around the core called the Rehabilitation Sub-Area.

The staff has recommended that both areas remain in their current residential use—primarily single-family and duplex—but, further, the staff has recommended that "no non-residential zoning changes be granted in either of these sub-areas."

In effect, if the City follows those recommendations, the plan would stop retail and office encroachment in that area.

Council members agreed with the staff recommendations on the retention of the residential zoning, but several Councilmen expressed reservation about rehabilitation of the small wood-frame houses characteristic of the Rehabilitation Sub-Area.

"The Preservation Sub-Area (Hibernia-State-Thomas) looks well worth preserving," said Mayor Folsom, "but that other area looks like it's just standing there. It doesn't look like you've got much to rehabilitate."

Planner Stanland pointed out that the success of the plan basically revolves around the success of individuals in preserving the core area and along Woodall Rodgers, because what happens there will determine what happens in the Rehabilitation Sub-Area.

"One saving grace," said Susan Murphy, "is the neighborhood had a lot of black aristocratic families who lived there and, even though a number of them got squeezed out (when major thoroughfares were put through the area), and moved to Oak Cliff, there are a lot of people who still own property there who care. People like A. Macee Smith and the MacMillan and Saunders families."

Another factor working to save the residential quality of the neighborhood is the high percentage, relative to other inner-city neighborhoods, of owner-occupancy, according to the planners. Of the 501 structures in State-Thomas, 95 are owner-occupied and that number is increasing.

But a small number of that increase involves a white population which has moved into the "Preservation Sub-Area," buying the grand Victorian structures to renovate.

In his presentation to the Council, Stanland said the people in the neighborhood requested that the "cultural heritage be

preserved," a euphemism for keeping the neighborhood black.

"We can't address that," explained Ms. Murphy, "because we can't control who is going to buy property. Hibernia (Street) is going white, although there are a couple of blacks who have moved in."

"The neighborhood group needs to get a strong, representative organization and recruit people to move in," she suggested.

The staff does not recommend that the area organization be broad, including owner-residents, absentee-owners, businessmen and renters for the implementation of the plan.

Even if the old State Theater were not preserved as a black cultural or arts facility, as it sometimes is rumored, that area of State and Hall will probably always be known for its place in black history.

Black musicians used to come to jam at the Green Cape, a place upstairs and around the corner from the old State Theater. Names like Duke Ellington are dropped when people talk about the history of those small shops and hotels, where the black musicians stayed when they were in town.

The staff recommends that small retail area be retained, serving as a community service center for the State-Thomas Study Area.

The study also has recommended that the citizens work with Traffic Operations, Department of Streets and Sanitation, to solve the circulation problems within the area.

Just last week, the Inner City Improvement Committee, predominantly composed of black residents of the area, met with the City staff, because they heard Routh was going to be expanded on the other side of Woodall Rodgers, thus posing a threat to their neighborhood.

The possibility of using diverters was discussed and committees have been set up to work with the City to help alleviate an increase in traffic through the neighborhood, according to DAC worker Ann Dooley.

The City also has recommended capital improvements so that sidewalks, curbs and gutters in need of repair or replacement in the Residential Preservation Sub-Area be achieved in a multi-year program.

All the staff recommendations will be used by City Departments setting priorities for their expenditures, explained Stanland, and the study will be used as a guideline for the Council in evaluations such as zoning.

State-Hall area's known for place in black history.

NORTH

Greenwood Cemetery

Griggs Park

NORTH CENTRAL EXPWY.

FAIRMOUNT

MAPLE

PEARL

WOODALL RODGERS FRWY.

Commercial
Redevelopment
Rehabilitation
Core Preservation

By 1977, the Thomas and Hall business area around the former State Theater was fading. Residents were leaving. Structures were being demolished. Properties were sliding into disrepair. According to a *Dallas Downtown News* article by Lyn Dunsavage that ran April 23, 1979, residents appealed to the City of Dallas in 1977 to do a study of their area. The city complied, and study recommendations were presented last week. They called for residential redevelopment along Woodall and preservation of the historic core, as shown on this map. "The core area looks well worth preserving," said Mayor Folsom. City manager Ray Stanland pointed out that the success of the plan revolved around the success of individuals in preserving their core area. "The neighborhood group needs a strong representative organization to recruit people to move in," said senior city planner Susan Murphy. The study also recommended that residents work with traffic operations to solve the circulation problems within the area. Armed with the recommendations, the neighbors began their work.

Six

STATE-THOMAS
PRESERVED AND REIMAGINED

Around 1977, an ambitious problem-solving journey began to preserve part of the oldest Dallas neighborhood still intact and to imagine another. The result was the State-Thomas Historic District and a new master-planned State-Thomas around it.

In 1979, Arthur Hughes and Judy Smith Hearst led the neighborhood in the first of many petition drives to stabilize, then preserve the neighborhood through zoning and planning. Zoning change required a majority of a contiguous area. Judy carried the petition and made the case with every home and business in 96 acres. Attorney Richard Levin and neighbors sought relief from excessive demolitions. In 1980, attorney Susan Mead became neighborhood legal counsel. The city council unanimously passed the zoning request for the area that eventually became the historic district.

The Friends of State-Thomas neighborhood group was formed with Judy as the first president. Urban pioneers architect Al Cox and renovator John King joined.

The group tackled the second critical problem of cut-through traffic and petitioned for the Maple-Routh Connector, an innovative solution to reroute traffic around the neighborhood.

In 1984, protection came with city council's adoption of the State-Thomas Historic District.

Buoyed by these anchors, the Friends of State-Thomas and the City Planning Department led a series of public meetings with property owners of 96 acres to create a master-planned State-Thomas. A partnership developed with landowners of the 24-acre historic district, 30-acre landowner Lehndorff Ltd., president Tom Lardner, and all remaining landowners. Joint recommendations guided RTKL to create an urban-style master plan, containing residential, office, and retail. City council adopted this as Planned Development #225, March 1986.

Attorney Susan Mead initiated Dallas's first Tax Increment Financing District (TIF), allowing tax increases to fund desperately needed infrastructure.

Patricia and Curtis Meadows completed the first new residence under the ordinance in 1987. Patricia became the next president of the Friends of State-Thomas and later president of the TIF Board.

Today, the historic district complements a new mixed-use, urban neighborhood, thanks to the determination of pioneering resident leaders who took charge of their destiny against significant odds.

The Dallas Morning News

Texas' Leading Newspaper

JOE M. DEALEY
Publisher

JAMES M. MORONEY JR.
President

JOHN A. RECTOR JR.
Executive Vice President

ROBERT W. DECHERD
Executive Vice President

J. WILLIAM COX
Vice President, Controller

BURL OSBORNE
Executive Editor

Editorial Page

Jim Wright, Editorial Director

MONDAY, OCTOBER 27, 1980

State-Thomas Zoning:

Preserve Past, Future

There is more to Dallas than the image of a gleaming modernistic city that many hold. The city's history is preserved in its buildings and its neighborhoods. And the future of one of those neighborhoods is on the line before the City Council this week.

The council is being asked to backzone a 12-block area just north of Woodall Rogers Freeway to preserve its historic character and to further the revitalization of a unique inner-city neighborhood.

Called the State-Thomas area, the neighborhood contains some of the finest examples of Victorian architecture found in the city. In addition, the area was the site of one of several Freedman Towns settled by freed slaves after the Civil War.

While the area's historic credentials are unquestioned, the developing spirit of neighborhood it reflects is as important. For years it was an all-black enclave, but today it is an area in transition as urban pioneers are moving in and renovating the beautiful old homes. Blacks and whites, young and old are enthusiastic about revitalizing the area, about retaining it as their home.

Unfortunately, much of the area has been zoned for high-rise offices and apartments, which threatens its basic character. The City Plan Commission approved a planned development designation that would protect commercial investors while maintaining the residential character of the neighborhood.

But the City Council must concur. The case presents the dual goals of preserving Dallas' historical heritage and of encouraging the redevelopment of the spirit of neighborhood that is too often missing in big cities. The council should enthusiastically endorse both with an affirmative vote on the zoning change.

Titled "Preserve Past, Future," this *Dallas Morning News* editorial published October 27, 1980, detailed the reasons to support the preservation of State-Thomas. Arthur Hughes and Judy Smith Hearst spearheaded the drive to garner property-owner support for zoning changes to preserve the neighborhood. Longtime Thomas Avenue homeowners James Otto and Frankie Scott welcomed the opportunity to stabilize and improve the neighborhood and encouraged interested urban pioneers to become a neighbor, to buy and live in a neglected or absentee owner home, already tagged for demolition. From left to right in the above image are Judy Smith Hearst, Sandy King, and neighbor/homeowner Allean Fegan; the center image is of teacher James Otto, and the below image shows Frankie Scott, of the Crawford Funeral Home family. (Above, photograph by Arthur Hughes; center and below, photographs by Judy Smith Hearst.)

The first neighborhood brochure with recommendations from the City Planning Department's April 1979 Victorian Architecture and Neighborhood Conservation Study accompanied the petition in the first of many drives to preserve and rebuild the neighborhood through appropriate zoning and planning. The petition was presented to all 96 acres of State-Thomas. A majority of the owners in what would eventually become the 23-acre historic district signed in favor of the new zoning. (Judy Smith Hearst.)

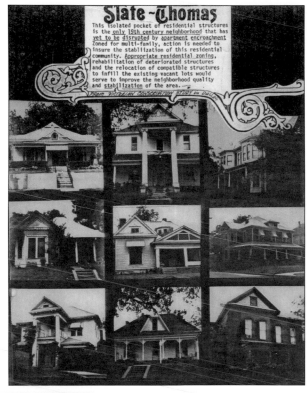

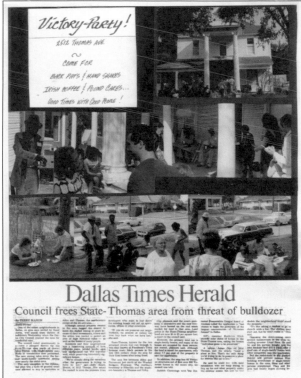

"Council frees State-Thomas from threat of bulldozer," and State-Thomas celebrates the first of many victories. The area to be preserved now had a boundary line. Neighbors felt their "wagons were in a circle" against an idling bulldozer. Spirits were raised to tackle a long work list ahead. They needed to move immediately to find cut-through traffic solutions before new developments were built out on vacant areas. (Hearst Collection.)

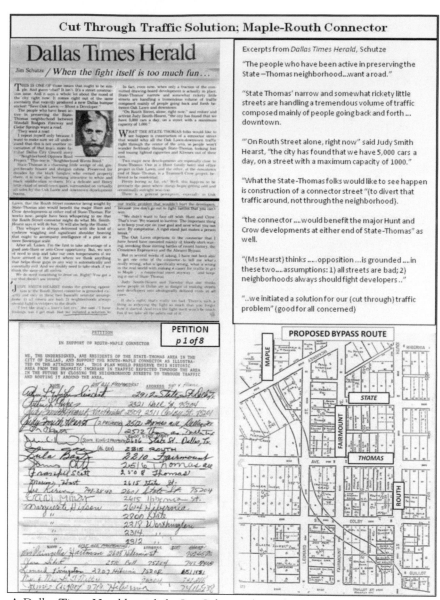

Dallas Times Herald

Jim Schutze / When the fight itself is too much fun...

[Newspaper article text — illegible at this resolution]

Excerpts from *Dallas Times Herald*, Schutze

"The people who have been active in preserving the State–Thomas neighborhood...want a road."

"State Thomas' narrow and somewhat rickety little streets are handling a tremendous volume of traffic composed mainly of people going back and forth ... downtown.

"'On Routh Street alone, right now" said Judy Smith Hearst, "the city has found that we have 5,000 cars a day, on a street with a maximum capacity of 1000."

"What the State-Thomas folks would like to see happen is construction of a connector street "(to divert that traffic around, not through the neighborhood).

"the connectorwould benefit the major Hunt and Crow developments at either end of State-Thomas" as well.

"(Ms Hearst) thinksopposition ...is grounded in these two....assumptions: 1) all streets are bad; 2) neighborhoods always should fight developers .."

"..we initiated a solution for our (cut through) traffic problem" (good for all concerned)

PETITION p 1 of 8

IN SUPPORT OF ROUTH-MAPLE CONNECTOR

WE, THE UNDERSIGNED, ARE RESIDENTS OF THE STATE-THOMAS AREA IN THE CITY OF DALLAS, AND SUPPORT THE ROUTH-MAPLE CONNECTOR AS ILLUSTRATED ON THE ATTACHED MAP. THIS PLAN WOULD PRESERVE THIS HISTORIC AREA FROM THE DRAMATIC INCREASE IN TRAFFIC EXPECTED THROUGH THE AREA BY CLOSING THE NEIGHBORHOOD STREETS TO THROUGH TRAFFIC AND ROUTING IT AROUND THE AREA.

PROPOSED BYPASS ROUTE

ABOVE: A *Dallas Times Herald* article by Jim Schutze about the Routh-Maple Connector reported the surprise of many that the cut-through traffic solution by State-Thomas property owners would actually simultaneously help developers. **BELOW:** The neighborhood group initiated and petitioned for a Routh-Maple Connector to reroute cut-through traffic to downtown that used the neighborhood streets of Routh and Allen. It was a long and difficult effort that promoted a creative solution and ended in success for all involved. It took many years of meetings with surrounding neighborhoods and property owners. After the project was finally approved and built, the cut-through traffic disappeared. Neighborhood streets were available for the growing numbers of neighborhood residents, visitors, and businesses. A beautiful road now connects the Arts District to The Crescent and McKinney Avenue area in Uptown. Often erroneously maligned as antidevelopment, State-Thomas has many examples of the supportive relationships between preservation and development, homeowner and developer, that led to the desirability and beauty of State-Thomas. (Page from neighborhood scrapbook, Hearst Collection.)

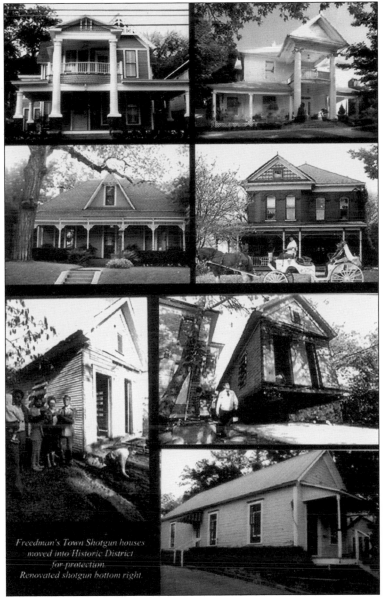

Freedman's Town Shotgun houses
moved into Historic District
for protection.
Renovated shotgun bottom right.

This composite features some excellent examples of Victorian architectural styles, including (first row) two late-Victorian Classic Revival style homes with two-story fluted columns facing each other at 2515 and 2512 Thomas Avenue; (second row) an Eastlake Victorian at 2620 State Street, and a Queen Anne cottage at 2615 State Street. Below right are two 1890 Victorian shotgun houses moved from Freedman's Town in 1982 to make way for an electric power substation. The neighborhood negotiated for the cost of moving and for a deed-restricted greenspace next to the substation where the shotguns had been located. They are now at 2312 and 2315 Routh Street. In below left image are, from left to right, neighbors David Doyle, Al Cox, Judy Smith Hearst, and James Otto, offering champagne toasts to the new arrivals. This is another example of the cooperation between developer and neighborhood group that has led to a more interesting and vibrant area of progress and preservation. The greenspace remains today for the neighborhood. (Hearst Collection; above right, Steve Clique.)

THE DALLAS DOWNTOWN NEWS

Volume 9, Number 29 June 2–June 8, 1986 50 Cents

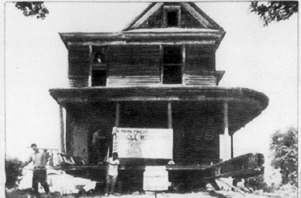

Mark Finch's $10 house in the State-Thomas area.

State Thomas—
Where it's been
and where it's going

By LYN DUNSAVAGE

A half-block away from a dilapidated wood frame house, on the front porch of which a sleeping black man whiles away the hot afternoon, a vacant lot in the State-Thomas Historic District has a curb which has been spray-painted with a large number — 2707.

Two blocks away, on yet another hill, a skeleton of a Queen Anne house, devoid of all paint, doors, windows and adornments, rests solidly on steel beams — those used to move houses. Attached to the front of that structure is an enormous, hand-made sign proclaiming, "This is Mark Finch's new home. Please handle with care. Thanks from the neighbors and friends," and is signed by dozens of signatures, sprawled in disorganized array.

The graffitied number and the moved-in house are the celebration of State-Thomas. They are just two indicators of how far that small neighborhood sandwiched between Downtown and McKinney Avenue has come and just where it is going.

2707 was "spray-graffitied" by Patricia Meadows, who, with her husband, Curtis, is building the first new-construction residential home in the State-Thomas Historic District in almost eighty years. (There was a 50s-style brick which replaced another structure years ago, but that is discounted by neighborhood leaders as "new construction).

Continued on Page 3

State-Thomas:
Redevelopment
'boom' has begun

Architectural rendering of Curtis and Patricia Meadows' new home in the State-Thomas area.

You're getting

By the time the historic district was declared in 1984, it had lost many homes to demolition or fire. Historic house moving projects and new construction were both encouraged as infill for the vacant lots. The article above by Lyn Dunsavage appeared in the *Dallas Downtown News*, June 2, 1986, and announced two such projects. The first (pictured above) was an endangered Victorian moved into protective zoning of the historic district: "The Victorian on Hibernia Street, owned by Mark Finch, is a concrete symbol of the victory so many of the residents have fought for to preserve the largest concentration of Victorians in Dallas." The second (pictured below) was the home of Patricia and Curtis Meadows, due to be completed in 1987, to be the first built under the new ordinance: "Patricia Meadows says they are undertaking new construction in the State-Thomas area—rather than renovation. . . . [it] will be a two story brick house with a high pitch roof . . . approximately 7,000 sq ft, including porches and garage." It beautifully complements the historic district as new construction. (Meadows and Hearst Collections.)

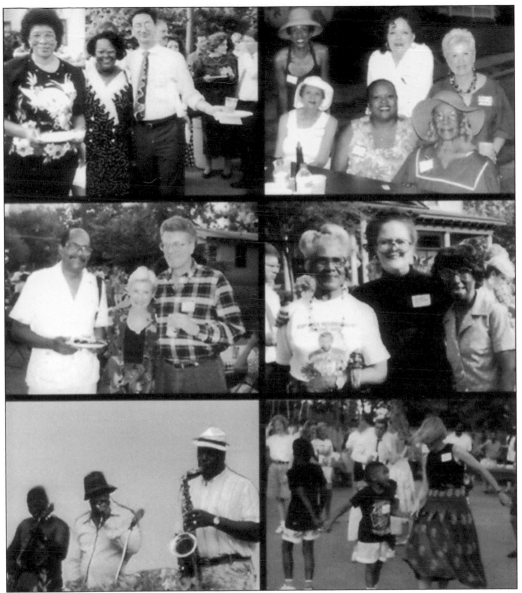

The State-Thomas neighborhood works hard and celebrates its successes. There have been many. A few celebrations from the past 20 years are featured here. **ABOVE LEFT:** Bea Hunter, Maxine Willi, and Jim Anderson. **ABOVE RIGHT:** (seated) Ruth Sanders, Marion Sims, Princella Hartman; (standing) Leena Sanders, Judy Smith Hearst, and Patricia Meadows. **CENTER LEFT:** Dr. Robert Prince, Patricia Meadows, and Earl Latimer. **CENTER RIGHT:** Princella Hartman, Judy Smith Hearst, and Ruth Kirven. **BELOW LEFT:** Neighbor and postman Tommy Flowers and his band. **BELOW RIGHT:** Susan Mead dances with neighborhood children. (Meadows and Hearst Collections.)

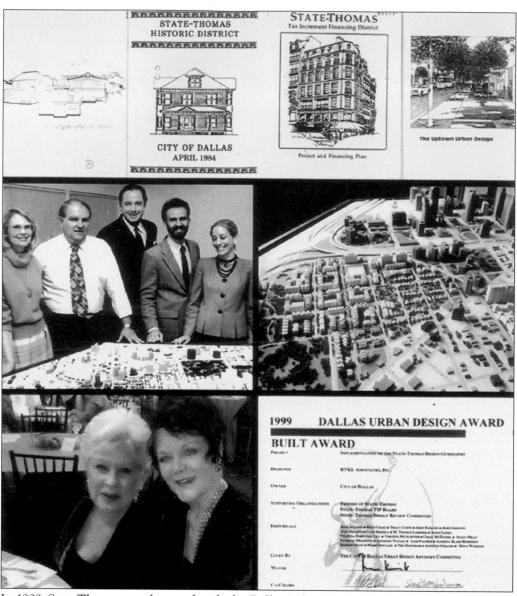

In 1999, State-Thomas was honored with the Dallas Urban Design Built Award. **ABOVE ROW:** Four of the State-Thomas planning documents since the late 1970s. Some recipients are pictured above. **CENTER LEFT:** From left to right are Virginia McAlester, Doug Waskom, Tom Lardner, Al Cox, and Susan Mead. (Courtesy of Virginia McAlester.) **CENTER RIGHT:** Scale model of State-Thomas Master Plan. (Courtesy of Patricia Meadows.) **BELOW LEFT:** Patricia Meadows and Judy Smith Hearst. (Courtesy of Nancy Starr.) **BELOW RIGHT:** Recipients of the 1999 Dallas Urban Design Award, Built Award, include, in alphabetical order, John Allums, Rick Craig, Tracy Curts, John Ignatis, John Gosling, Judy Hearst, Cliff Kehely, M. Thomas Lardner, Jason Leeds, Veletta Forsythe Lill, Virginia McAlester, Craig McDaniel, Susan Mead, Patricia Meadows, Anthony Natale, Lori Palmer, Alberta Blair-Robinson, Robert Shaw, Mark Sinclair, The Honorable Annette Strauss, and Doug Waskom. Many more people contributed to the success of State-Thomas. So many interesting and colorful people and events that could not be covered here but will be in books to come.

Seven

THE MATA ERA
A DREAM BECOMES A REALITY

In 1981, an Uptown Merchants Association plan to "back date" five blocks of McKinney Avenue by stripping off the asphalt to uncover the old brick pavement revealed that original streetcar rails still existed in the bricks as far as St. Paul Street. In 1983, the nonprofit McKinney Avenue Transit Authority, with Phil Cobb as its chairman, was incorporated to build and operate a trolley line. Startup money came from many sources, including $3 million from Phil himself. In 1983, he purchased MATA's first trolley in running condition, ex-Portuguese car 122.

On January 23, 1986, MATA was granted operating franchise.

The fledgling agency purchased Melbourne, Australia, class W-2 trolley 369 in running condition. Chief mechanical officer Ed Landrum provided two former Dallas trolley car bodies. Corporate sponsors funded the restoration of each of MATA's trolleys.

Track work began in April 1988, and installation of the overhead wire started on Memorial Day 1989.

The line's grand opening weekend began with a Good Golly, Great Trolley gala on the evening of July 21, 1989. On July 22, Get Back on Track day featured a ceremony at the carbarn, a 70-unit parade on McKinney to St. Paul, and an all-day McKinney Avenue street fair.

Initially, about 2,000 people a day rode the newest novelty in town. With the onset of winter, however, patronage dropped dramatically. To stay in business, MATA reorganized its entire staff in January 1990 and began a successful intensive promotion and marketing campaign. Many special events raised public awareness and increased patronage.

Because of a delayed $300,000 federal grant, in September 1991 MATA volunteers offered to run the company free of charge, and they did so successfully, maintaining a reduced daily schedule and growing the charter business. Rosie returned to the rails, and full-time service was reinstated on May 14, 1992, the day after receiving the long-awaited grant.

During 1994, the State Transportation Commission awarded MATA $5,590,000 to finance the line's expansion to the north and transition it from a tourist attraction to a real transit company. In Phil Cobb's words, "We are in a go-ahead mode now!"

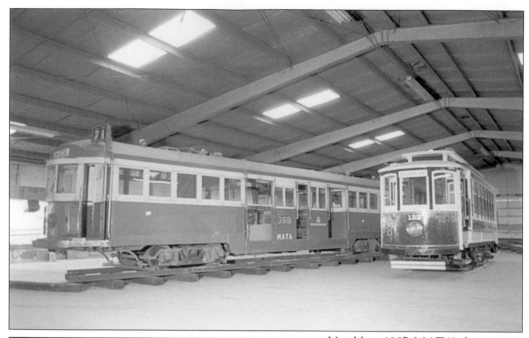

Until late 1987, MATA's first two trolleys in operating condition—former Melbourne, Australia 369 and former Porto, Portugal 122—were stored in an Uptown warehouse donated by Rosewood Properties, 122's corporate sponsor. MATA's first trolley, a former New Orleans car was sold back to that city to finance the purchase of 369. (MATA Collection.)

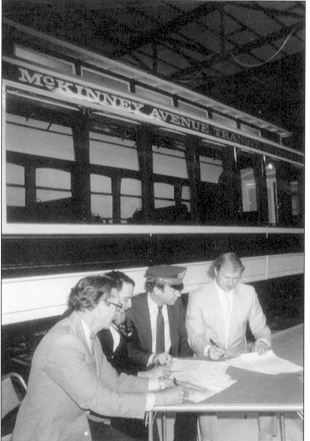

At 2:08 a.m. on January 14, 1986, exactly 30 years from the time the first Dallas streetcar era ended, MATA officials signed a lease for a former Carpet Warehouse on Bowen Street to be used as a carbarn. From left to right are Ed Landrum, Harry Nicholls, the building's owner, and Phil Cobb. (MATA Collection.)

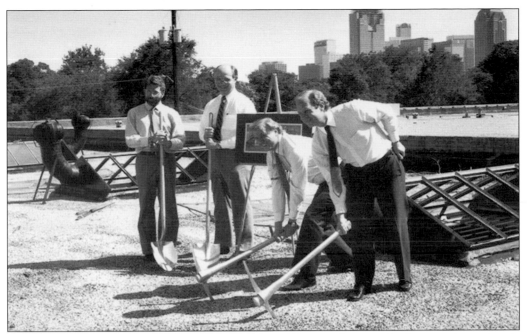

Most building projects begin with a ground-breaking. However, because the future carbarn already existed, and the roof needed to be raised by seven feet to accommodate the trolleys, MATA officials held a roof-breaking ceremony on April 24, 1987, to kick off the remodeling. The work was expected to be finished in three months. (MATA Collection.)

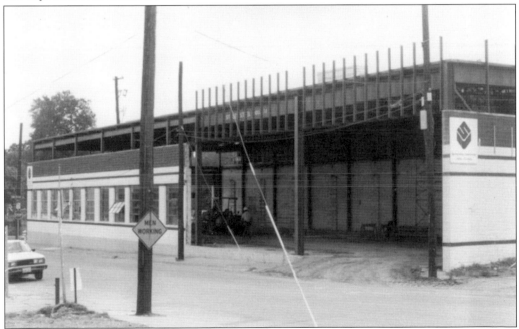

This view from McKinney Avenue shows the warehouse remodeling progress as the roof was being raised. Not visible, but very important, was also redoing all the plumbing, heating, and electrical work, removing the existing concrete floor, rebuilding the offices, and digging a service pit. Trolley-car-sized doors would also be installed. (MATA Collection.)

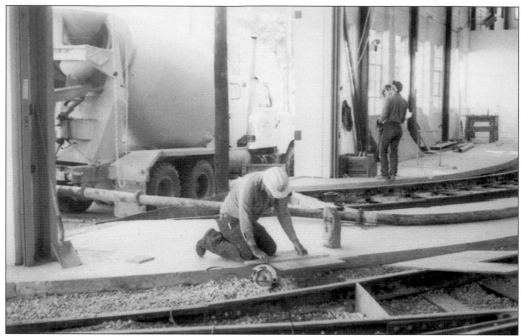

To complete the transformation of the warehouse into a carbarn, tracks and switches were laid in the building, and new concrete flooring was installed around them. A time capsule was also buried underneath the new floor. A solid-state rectifier was installed to convert city current to the 600-volt DC electricity needed to run the MATA trolleys. (MATA Collection.)

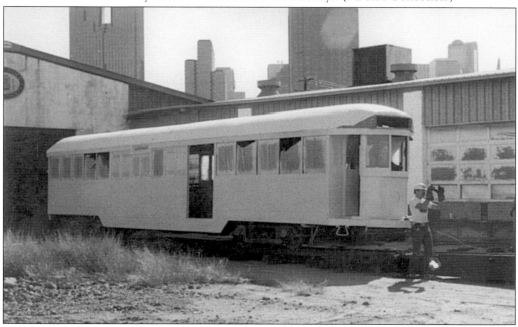

In November 1987, partially "Americanized" trolley 369 in its primer paint is being loaded onto a flatbed truck for the journey to its new home on Bowen Street. Built in 1926, this car is one of a group of "W-2 class" trolleys that Melbourne, when modernizing their streetcar fleet, sold to several American cities. (MATA Collection.)

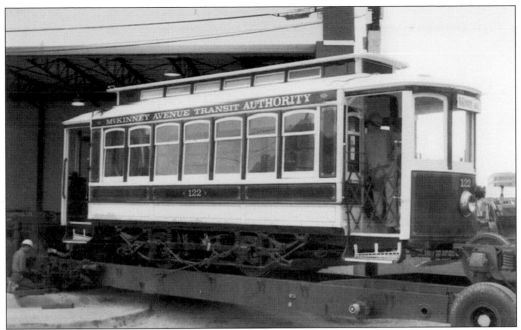

Car 122, having just arrived at the new carbarn, waits her turn to be unloaded. Built in America for Porto, Portugal, the car ran there until 1980. San Francisco purchased it for their annual Trolley Festival. Phil Cobb saw the car there and bought it for MATA. The car is fully restored and ready to run. (MATA Collection.)

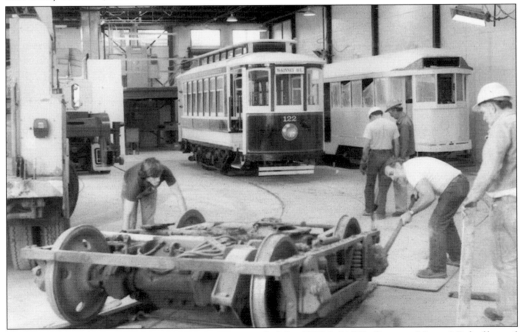

To keep the trolleys running, spare parts are needed. In 1987, MATA director Harry Nicholls and some volunteers are unloading extra Australian trolley trucks that were purchased at the same time as trolley 369. On the right-hand side of the photograph is MATA's ex-Dayton, Ohio, line truck that would be used to help maintain the overhead electric wires. (MATA Collection.)

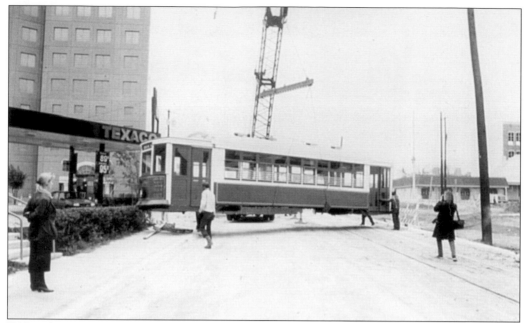

Ed Landrum restored the body of 1913-vintage Dallas trolley 186 and put it on display at the Texas Sports Hall of Fame between Dallas and Fort Worth. The museum closed in 1986, and 186 found a new home at MATA. The trolley arrived in November 1987 and was placed on shop trucks. It was later permanently outfitted with two Melbourne, Australia, streetcar trucks. (MATA Collection.)

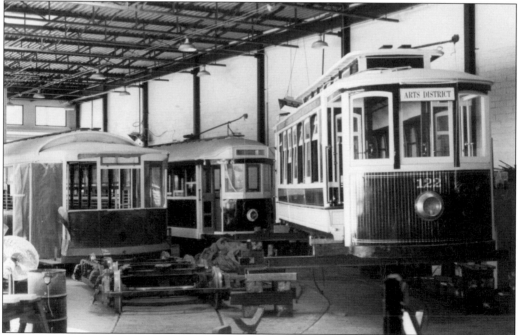

In April 1988, restoration continued in the carbarn. Cars 186 and 369 are being painted. Car 186 needs a headlight and a trolley pole, and 122's truck has been pulled for maintenance. The volunteers worked tirelessly to be sure all the trolleys could run on opening day in July 1989.

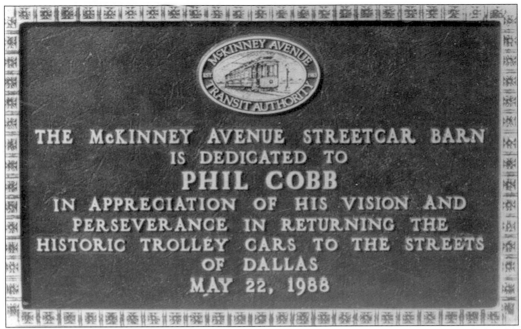

THE McKINNEY AVENUE STREETCAR BARN
IS DEDICATED TO
PHIL COBB
IN APPRECIATION OF HIS VISION AND
PERSEVERANCE IN RETURNING THE
HISTORIC TROLLEY CARS TO THE STREETS
OF DALLAS
MAY 22, 1988

This plaque affixed to an exterior wall of the carbarn rightfully dedicates the building to Phil Cobb for his tireless efforts to restore trolley service to Dallas. Although Cobb was the never-give-up leader of the project, the volunteer workers' many skills and talents were also an important asset that helped make the trolley line a success.

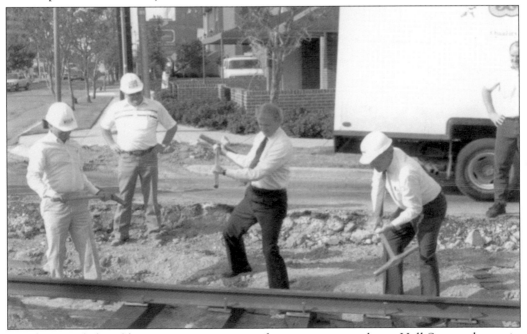

An almost unbelievable event—construction of new streetcar tracks on Hall Street—began in September 1988, proving that MATA was serious about getting its trolleys out of the carbarn and onto the streets of Dallas. At Hall Street near McKinney Avenue, Phil Cobb drives a "golden spike" to commemorate this milestone. (MATA Collection.)

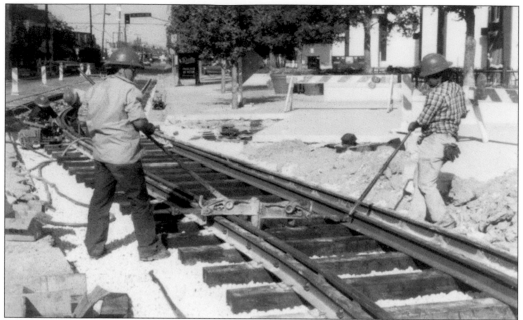

New track work is continuing at McKinney Plaza in October 1988. At this location, close to the intersection of McKinney Avenue and Hall Street, the curbside tracks swing off to the side of the avenue to provide a layover location for trolleys before they loop back on Hall Street, to Cole Avenue, to McKinney Avenue.

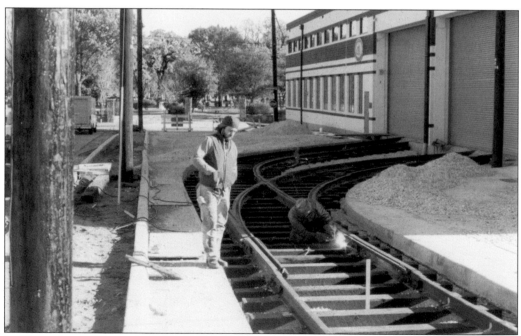

In November 1988, tracks on Bowen Street leading to the carbarn are being finished to give MATA's trolleys a connection to the main line. All the switches (often called "special work") on MATA's new trolley line were salvaged from old Texas Electric Railway and Dallas Railway & Terminal lines.

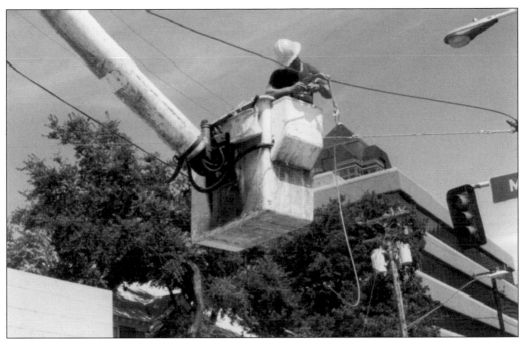

On Memorial Day 1989, installation began of the overhead electric wire from which the trolleys would draw their power. A worker is hanging wire at St. Paul Street and McKinney Avenue. Even though the contractor had never strung trolley wire before, the job was completed in a week's time. However, MATA's crews had to make several adjustments later to ensure smooth operating.

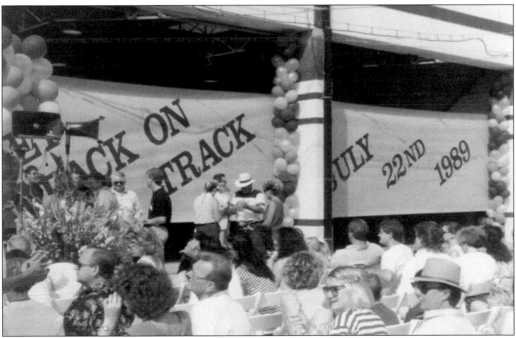

On the long-awaited day of July 22, 1989, the Get Back on Track grand opening of the trolley line began with a ceremony at the carbarn. Bowen Street was closed to traffic, and chairs were placed in the street for the invited guests and dignitaries who attended.

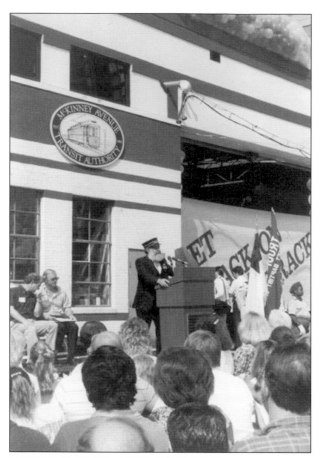

Several MATA officials addressed the crowd, including executive director Harry Nicholls. Among the speeches, was a tongue-in-cheek history of MATA based on the movie *Field of Dreams* and recognitions of individuals and businesses that had supported MATA. Mayor Annette Strauss proclaimed July 23–29 as Trolley Week in Dallas.

Much to the delight of everyone who had been sitting through the speeches in the hot sun, to conclude the ceremony, little 122 broke through the banner strung across the carbarn doors to signal the official return of trolleys to the streets of Dallas after a 33-year absence.

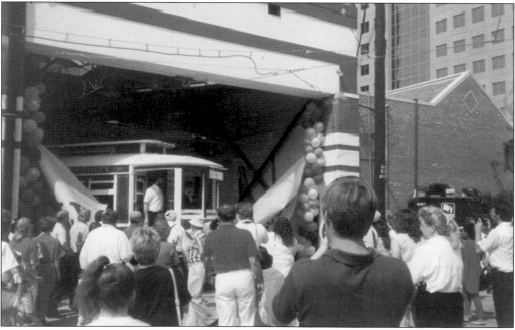

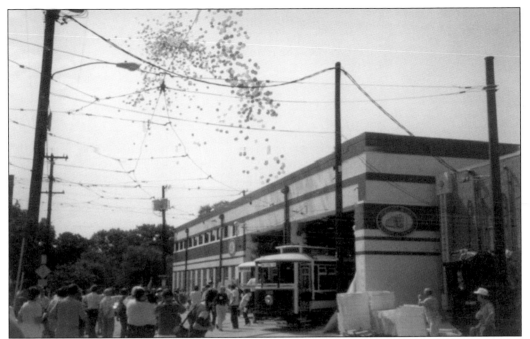

While the trolleys were lining up to take their places in the opening-day parade that would introduce them to the general public, a balloon release climaxed the end of the celebration at the carbarn. All the people who attended the ceremony boarded a bus to take them to a special parade viewing area. (MATA Collection.)

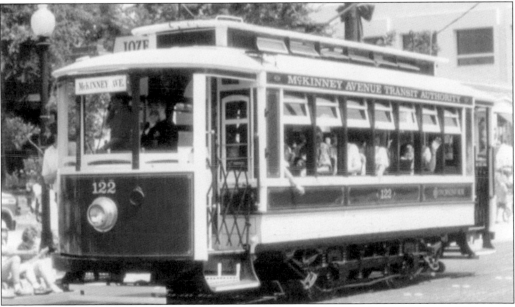

Large crowds, lining both sides of McKinney Avenue and crammed into every available space in the restaurants, got their first look at a streetcar as MATA's beautifully restored 122 led the opening-day, 70-unit Parade of Parades, and a banner along the route proclaimed, "Well, hello trolley . . . it's so nice to have you back where you belong." What more could be said than this? (Collins Color Photo Labs.)

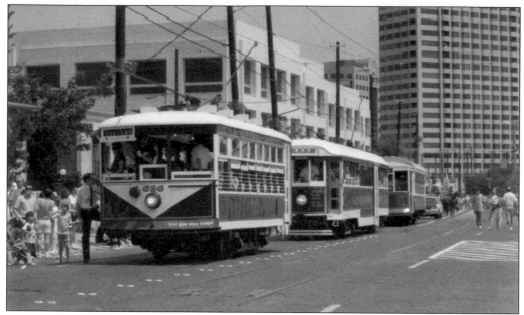

MATA's other three trolleys were the last entries in the parade. During the all-day street fair that followed the parade, cars 186 and 369 offered free rides around the "north loop," and 122 and 636 were put on display. A local newspaper estimated that the total attendance for the event was 30,000.

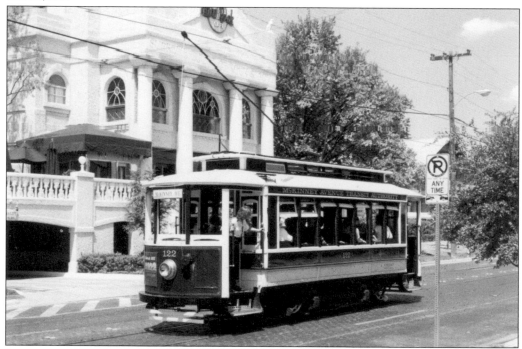

In revenue service, trolley 122 passes McKinney Avenue's Hard Rock Cafe. The Hard Rock was a good revenue builder for the line, as many people rode the trolleys there, but it moved to Victory Park in 2007. The 100-year-old building, formerly a Baptist Church, failed to receive landmark status, and the new owner razed it, tragically.

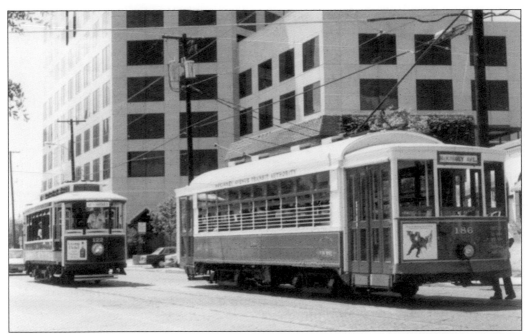

MATA soon became a busy railway. In September 1989, cars 186 and 122 meet on McKinney Avenue near Routh Street. Huge crowds were riding the newest novelty in town—the trolleys—everyday. The trolley was even listed among the top 10 attractions by the Dallas Convention and Visitors Bureau.

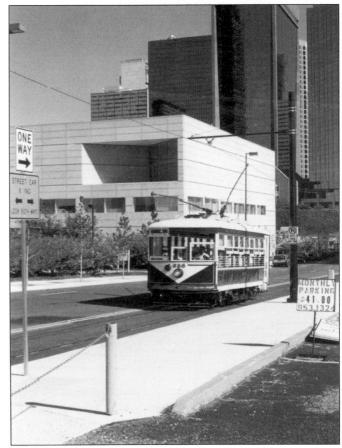

Although former Dallas Birney car 636 (later named Petunia) had participated in the opening-day parade, its interior had not been finished. The little car, built in 1920, finally entered revenue service on September 2, 1989, taking some of the load off the other three cars. The trolley is running against traffic on St. Paul Street.

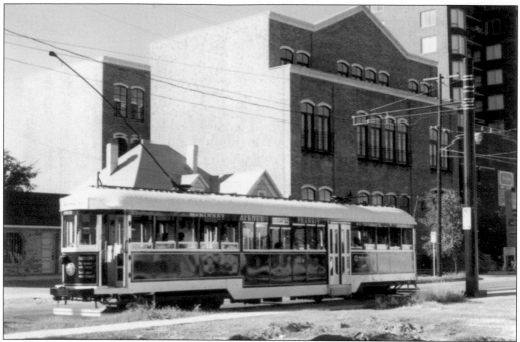

Former Australian car 369 (nicknamed "Matilda") is the biggest trolley in the MATA fleet. Over the years, she has proven to be a sturdy, reliable car and is popular for charters. On September 17, 1989, she has just crossed Bowen Street and is about to arrive at the McKinney Plaza layover.

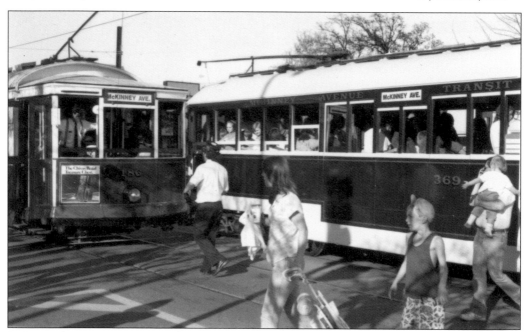

In September 1989, MATA is changing service cars. Trolley 186 has been waiting at McKinney Plaza for the arrival of car 369. Passengers who want to continue riding can board 186, which will soon depart for St. Paul Terminal. Car 369 will reverse direction and run against traffic on McKinney Avenue to Bowen Street and into the carbarn.

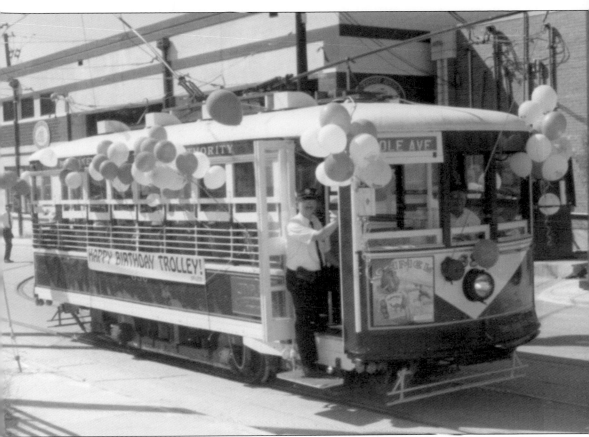

MATA celebrated its first birthday on July 21, 1990. Uptown restaurants and hotels donated cakes that MATA volunteers served free of charge all day to all riders on board the trolleys. This started an annual tradition that lasted through 1999. Each year, the birthday parties became more elaborate, as new attractions were added.

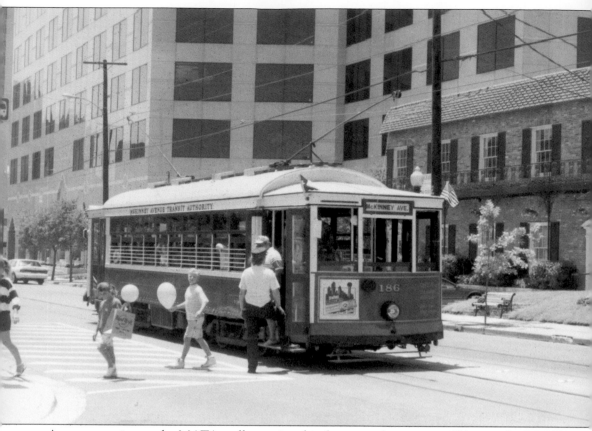

As an exception to the MATA trolleys painted in brown and cream, car 186 wore the DR&T prewar green color scheme. Streetcars running to SMU until 1951 were called Green Dragons by the students. So it was fitting that MATA's ex-Dallas car 186 would be christened the Green Dragon. The car is unloading passengers at McKinney Avenue and Routh Street in June 1990.

In October 1990, MATA's Trick or Trolley promotion let all children in costume who were accompanied by an adult ride free from the 26th through the 31st. The young riders were also given Halloween treats. On October 27, one of MATA's operators, dressed in costume, promises his passengers a devilishly good ride on car 636. (Petunia.)

Dallas hosted the Mrs. America Pageant in October 1990. On the 29th of the month, the contestants rode car 369 (Matilda). The lovely ladies posed for a publicity photograph in the carbarn before enjoying a unique and fun round-trip through Uptown. Not many beauty pageants include a trolley ride.

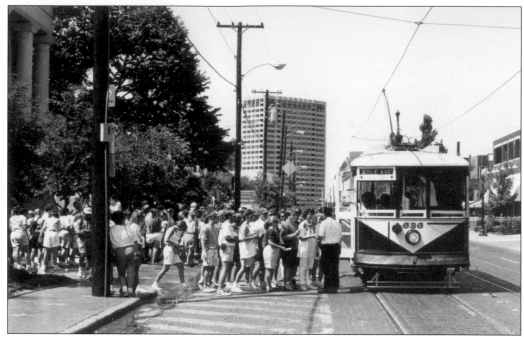

A total of 28,000 teenagers attended a Lutheran Youth Group Convention in Dallas for three days in July 1991. They all wanted to visit the Hard Rock Cafe, and most got there by trolley. MATA, overwhelmed with passengers, ran three streetcars at maximum capacity day and night, bringing in very welcome record revenues. (MATA Collection.)

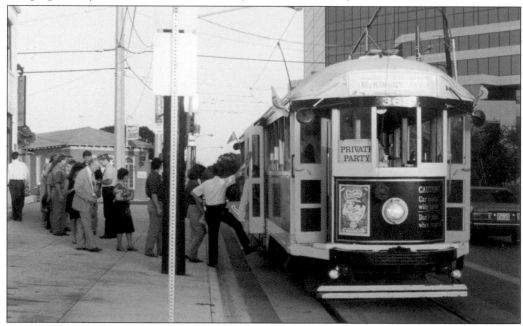

In 1991, Andrew's restaurant hosted a weekly mystery theater dinner. After cocktails, the patrons rode one round-trip on Matilda. Part of the play was acted out on the trolley, and on returning to the restaurant, the meal and the "crime" continued. Afterwards, the patrons sifted through clues to identify the "criminal." On July 13, diners are seen boarding 369 for an exciting trolley ride.

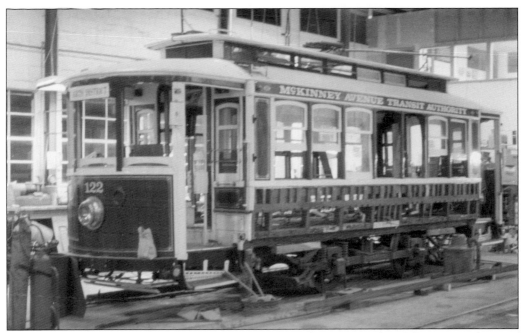

In 1991, trolley 122, now named Rosie, was starting to show the results of the wear and tear of her 82-year lifespan. She was retired to the barn and stripped down to her structural ribs as the first step of an almost yearlong complete rebuilding to make an old car new again.

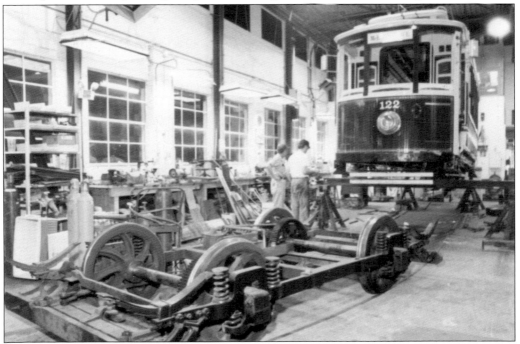

During Rosie's second restoration, MATA took the opportunity of removing her turn-of-the-century motors and sending them to an outside contractor for repair and refurbishing. Amazingly, there was one shop in Dallas that still had the expertise to repair Rosie's 1909-era "clamshell" electric trolley motors.

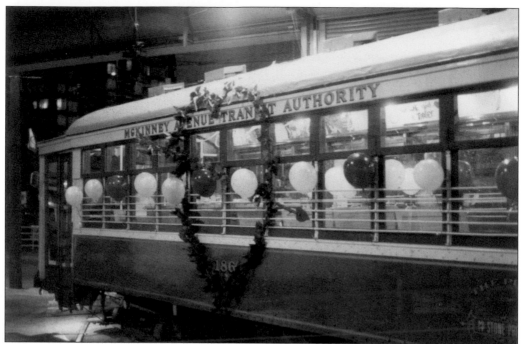

MATA launched a couples-only Love Trolley promotion for Valentine's Day in 1992. Hors d'oeuvres and sparkling grape juice were served during a round-trip on one of two decorated streetcars; one couple got so caught up in the romantic atmosphere that they became engaged on trolley 186. The event was so popular that it was repeated again in 1993.

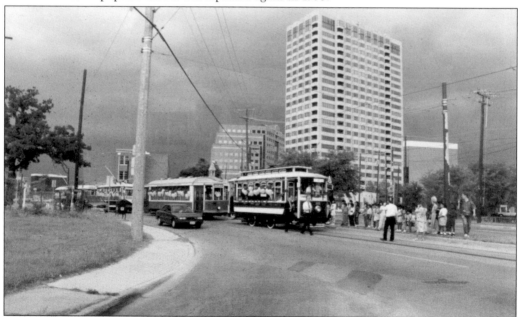

To celebrate the receipt of the delayed federal grant and Rosie's return to service, MATA staged a four-trolley parade on May 4, 1992. MATA dignitaries rode Rosie, and Travis Elementary School children rode the other three cars. On the same day, the full-time schedule that had been cut back in October 1991 was restored. (Roy Smith Estate.)

Birthday parties for children that include cake and maybe ice cream served on board continue to be MATA's most enduring and popular charters. Unique parties like this one in 1992 are not easily forgotten. Although children are especially entranced by a trolley ride, there is something about the venerable old trolleys that appeal to people of all ages.

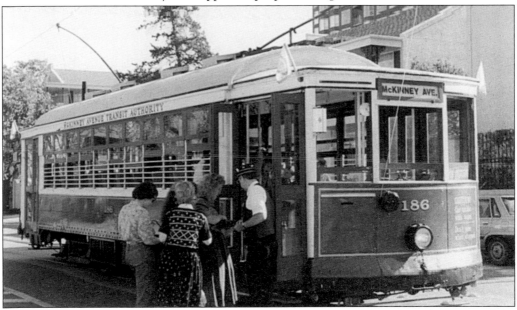

Because it once actually ran in Dallas, the Green Dragon (car 186) has always been one of the workhorses of MATA's fleet in regular revenue and is often requested for charter service. In this summer 1992 scene, all of the car's windows are open, and once 186 begins moving, the breeze blowing through the trolley will keep passengers quite comfortable.

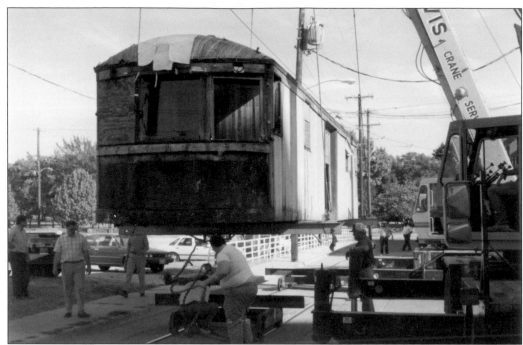

In September 1992, MATA acquired former North Texas Traction Interurban car number 332. On its arrival at the carbarn, it was placed on shop trucks and moved inside. Although the car was designed to carry freight, MATA planned to convert it into a deluxe dining car that might also run in regular revenue service.

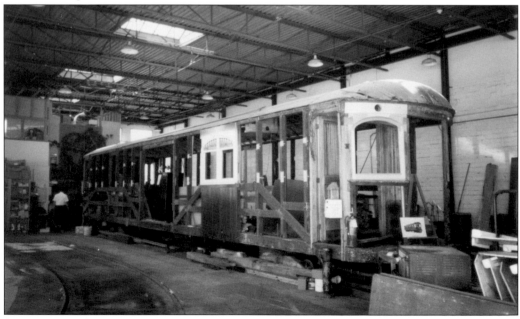

Since car 332 has no corporate sponsor, its transformation has been funded by voluntary contributions from visitors to the carbarn. However, the volunteers were eager to work on the car and already in 1994, its new identity was starting to manifest itself. The interurban also received a new name, the Morning Star.

Always looking for new promotions, MATA sponsored the first Dallas Mardi Gras parade in 1993. Streetcars, floats, and other entries marched down Allen Street and McKinney Avenue. Problems with a Dallas Cowboys victory parade the day before led several participants to cancel, but the MATA crowd was well behaved and enjoyed the downsized parade and its New Orleans atmosphere.

In July 1993, a German railfan club traveled across America visiting various trolley and light rail lines. They spent a day riding and photographing MATA's four trolleys and topped off their visit with a meal of fiery Tex-Mex food, served aboard Matilda, and then posed for a group photograph at St. Paul Terminal.

Eight

THE MATA ERA
UPS, DOWNS, AND STRAIGHT AHEAD

In March 1995, MATA received its first annual payment from the Uptown Property Improvement District. And in May, a municipal bond package that included $2.9 million for MATA's expansion passed by wide margin.

MATA purchased two retired Toronto PCC streetcars in April 1996. Volunteer Earl Leeson went there to close the deal and coordinate their shipment to Dallas.

To test the feasibility of trolley dining car service, in February 1998, MATA served full-catered meals on cars 186 and 369. The trolleys ran to capacity on both nights with four seatings on the 13th and two on the 14th.

The Electric Railroaders Association annual convention in Dallas included a visit to MATA. In addition to riding the trolleys, the railfans were treated to two demonstrations, showing how maintenance of way work could be done without disrupting revenue operations.

Because the 100-year-old brick pavement on McKinney Avenue between Allen and Pearl Streets had finally worn out, in July 1999, the city began to repave that section with concrete brick. MATA initially provided limited service during the project, but storm-drain work at McKinney Avenue and Clyde Lane in September shut down the trolley line completely. However, the construction presented MATA an opportunity to replace over 300 feet of worn-out tracks without having to rip up the old pavement around them. MATA finally resumed limited service on April 21, 2000, and reinstated full-time trolley service to the line on January 3, 2001.

Even better, construction began on the northward Cityplace West Village extension in 2001. After it opened on April 13, 2002, Dallas Area Rapid Transit (DART) enrolled MATA in its Site-Specific Shuttle program. MATA assumed a new identity as the M-Line, becoming a genuine transit company. With funding coming from several sources, all M-Line fares (except for charters) were dropped in August 2002. Patronage soared to more than 2,800 passengers a week.

The M-Line purchased a Tandy (Fort Worth) "subway" car in February 2003. It was originally a PCC streetcar, and the M-Line converted it back into one for testing.

Total ridership in 2003 (except for charters) set a new record: 152,049 passengers.

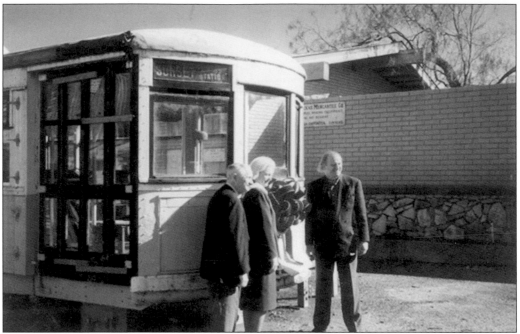

In December 1994, Ben Carpenter (son of the 1927–1935 Dallas Railway & Terminal Company president) and his wife, Betty, donated former Dallas trolley 754 to MATA. The car on their ranch in Irving, Texas, was in very good condition and had been a playhouse for his grandchildren for many years. (MATA Collection.)

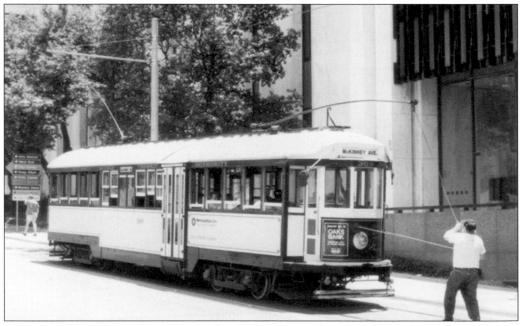

MATA's trolleys can be driven from either end. At St. Paul Terminal, operators have to change ends by lowering one trolley pole and raising the other before departing. The operator of newly repainted Matilda is doing this in April 1995. Because of the high tension in MATA's overhead wire, a trolley pole raised in the direction of travel would be badly bent.

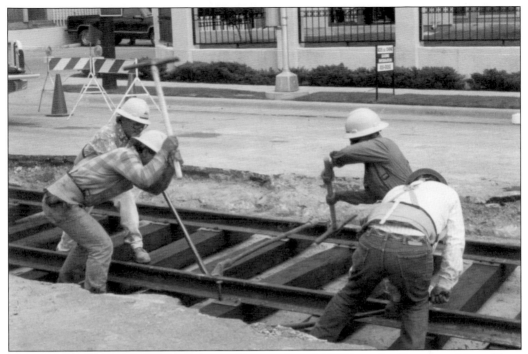

A subsidence on Cole Avenue caused a troublesome dip in MATA's tracks. To correct this problem, a contractor replaced 400 feet of track on that section of Cole Avenue, over a 10-day period in the spring of 1995. Despite all the modern machinery available, the old-fashioned way of spiking the rails to the crossties still seemed to work quite well.

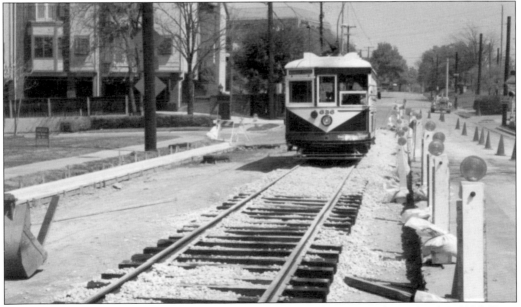

Petunia made one of the first trips on Cole Avenue over the new track on April 1, 1995. Even though the trolley was running on an unpaved part of the street, there were no problems as the tracks were rigidly set on wooden crossties in ballast. This part of the street was paved about a week later.

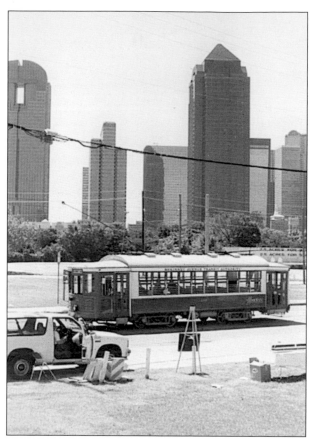

For its 1995 birthday party, MATA transformed a vacant lot next to the Crescent Complex into Trolley Park for a day, on July 22, 1995. Several displays and children's rides were set up there. MATA served its riders the usual free birthday cake on the 21st and again on the 22nd. The Green Dragon is passing Trolley Park en route to St. Paul Terminal.

Starting in 1993, MATA began decorating its trolleys for the Christmas season. Santa even rode the streetcars and gave the younger passengers candy. He was once spotted driving a trolley. Petunia, decked out for the holidays, is rolling down McKinney Avenue near Bowen Street on a gloomy day in December 1995.

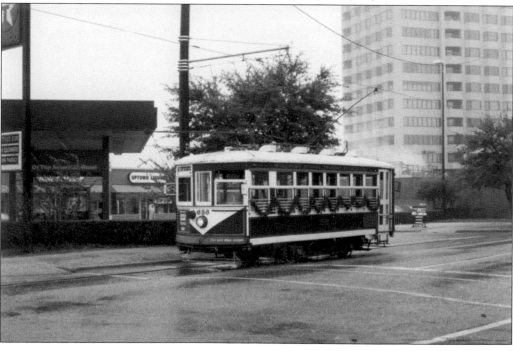

Also in December, two volunteers donated a fully operational speeder (a small gasoline-powered car used by railroads for track inspection and maintenance of way duties) to MATA. It had the potential to do the same for MATA. Work started immediately on a cosmetic restoration of the trolley line's first nonelectric rail car.

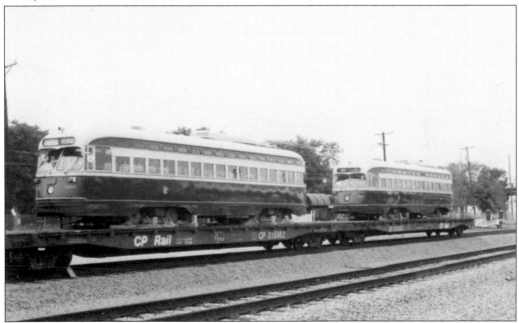

On May 24, 1996, MATA's former Toronto PCC streetcars arrived in Dallas and were switched into the Dallas Area Rapid Transit's (DART) maintenance facility yards. The cars had been extremely well maintained and were in like-new condition. Since the PCCs were single-ended trolleys, DART agreed to store them until loops could be built at each end of MATA's line.

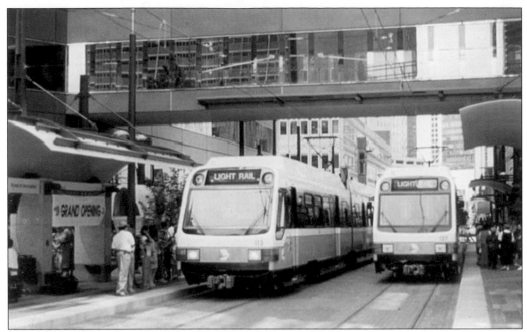

On June 14, 1996, a new era dawned in Big D when DART opened its 20-mile starter light rail lines. Now MATA was no longer the only electric railway in town. Dallasites became more rail conscious. DART's patronage exceeded expectations, and MATA's regular and charter business increased substantially.

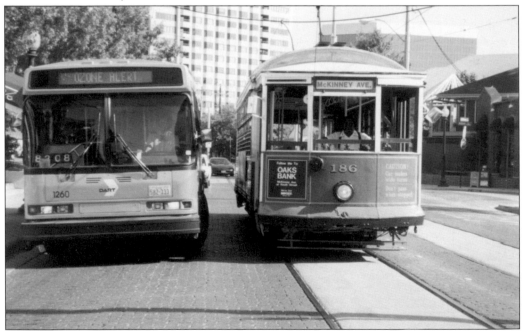

DART buses ran on McKinney Avenue as well as the trolleys. In this mid-1990s photograph, the Green Dragon passing a new DART diesel bus shows the contrast between the two types of transit vehicles. The 1913 vintage trolley may be old, but it can hold its own against the modern bus. (MATA Collection.)

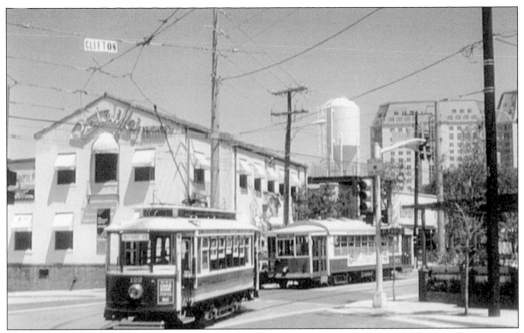

In July 1996, the Green Dragon waits for Petunia to clear the switch at McKinney Avenue and St. Paul Street. In 1991, MATA began the tradition of honoring volunteers who died while working for the company by naming a location on the line for them and hanging a small sign with their surname from the span wires there. This intersection is now known as Clifton by the MATA staff.

St. Paul is a one-way street. MATA's tracks, set in red brick pavement, are next to the curb. The tracks are profusely signed to warn other traffic of the reserved right-of-way, as the trolleys have to run both with and against traffic on the street. Motorists have respected this arrangement since the line's opening in 1989. Even MATA's smallest trolleys can be intimidating.

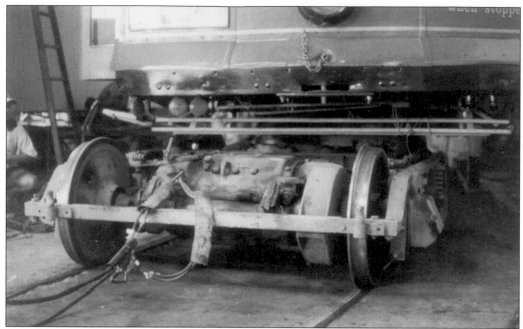

Ongoing maintenance is the key to reliable and safe operations. In June 1998, one end of the Green Dragon has been jacked up and one of its trucks is being removed, allowing MATA's talented and dedicated volunteer shop crew to work on its motor—either for repair or routine maintenance.

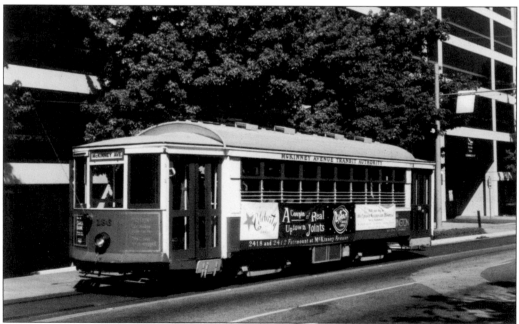

Having passed its June 1998 maintenance inspection, the Green Dragon is back in service and approaching the southwest end of the line: St. Paul Terminal. About this time, MATA began accepting exterior advertising on the sides of the streetcars. Initially, the advertisements were printed on canvas banners that were tied to the trolleys.

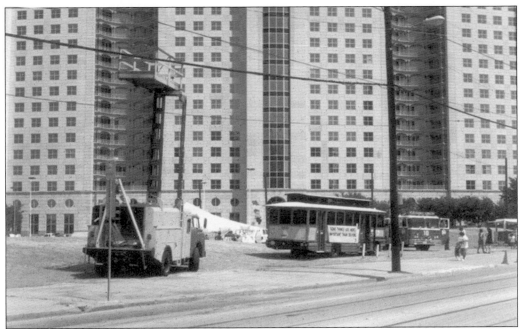

MATA's former Dayton, Ohio, line truck (used to service the overhead wires) with its worker's platform extended to its maximum height was one of the most striking 1998 birthday exhibits. Next to the truck is one of DART's mock trolley buses. The Crescent hotel and office complex, the owners of the lot, made a nice background for the festivities.

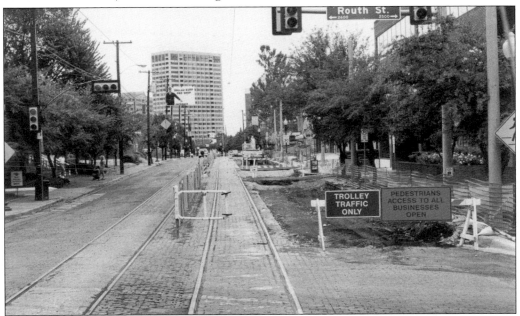

During the reconstruction of McKinney Avenue, work started on the southbound lane. MATA's trolleys ran both ways on the northbound side of the street in fenced-in areas. The trolleys pushed spring-loaded gates open where the fencing ended at intersections. At the southern end of the construction area, southbound trolleys ran over a temporary crossover to the correct tracks to continue their trips to St. Paul Street and Ross Avenue.

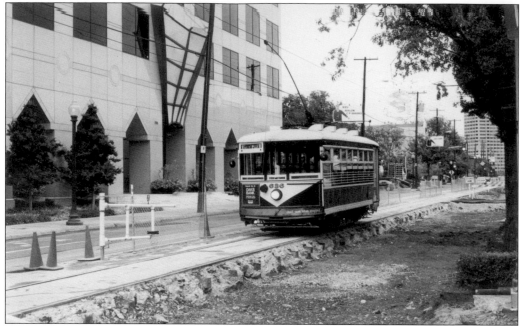

On September 5, 1999, little Petunia ran northbound "on the brink" as she headed for Bowen Street. The signs, hanging from the span wires, directed motorists to the entrances to various businesses along the avenue. The following day, the trolley line was shut down completely for several months as street repair continued.

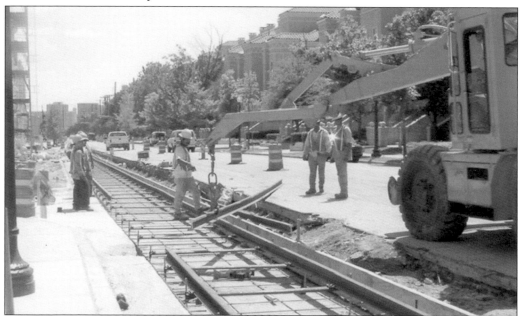

On a more positive note, in May 5, 2000, track laying for the new northward extension to the Cityplace West Village development began on Cole Avenue. A unique construction technique mounted the rails on metal risers, and proper gauge was maintained by metal rods separating the tracks. Rebar below the rails would hold concrete in place when poured around the rails. (Cassie Pierce.)

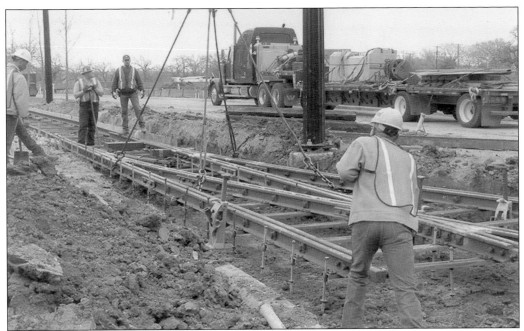

On July 3, 2000, workers are installing switches for the wye at McKinney Avenue and Cityplace West Boulevard. When viewed from above, the track junction looks like the letter Y, hence the name. This arrangement will enable trolleys to take their usual route from McKinney onto Cityplace West and back or, if necessary, continue straight ahead on McKinney Avenue. (Cassie Pierce.)

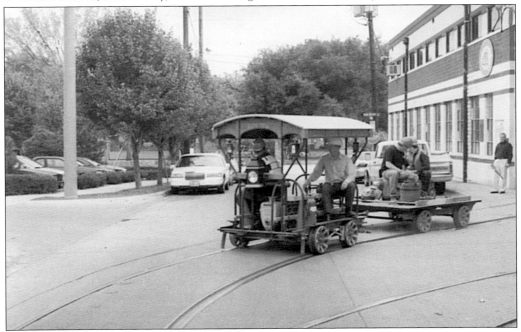

The speeder (Miss Daisy), her trailer, and a full crew are leaving the carbarn in December 2001. Miss Daisy proved her worth during the rebuilding of McKinney Avenue when the industrial-strength vacuum on the trailer was used to clear construction debris from the tracks while the trolleys were still running—and also after the line was reopened, once the street work was complete.

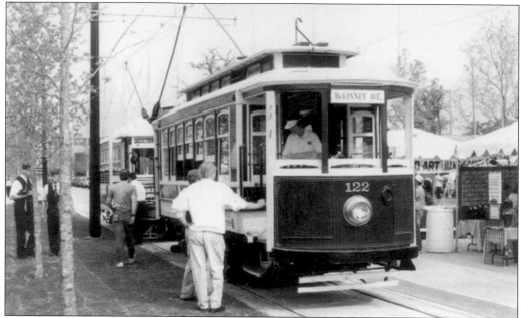

Rosie and Petunia are at the end of Cityplace West Boulevard on the opening-day celebration of the new extension on April 13, 2002. Entertainment and vendor's tents lined both sides of the boulevard. Petunia offered free rides all day from the end of the track to McKinney Avenue and back. A big-top circus climaxed the day's events.

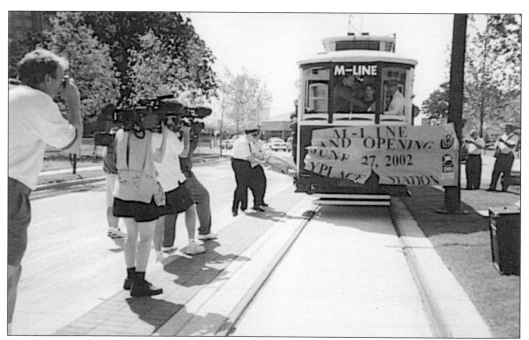

Since the end of MATA's Cityplace West Boulevard line enabled an easy connection to DART's Cityplace subway station, MATA became a DART transit partner and took on a new persona—the M-Line. The new identity was celebrated by a small ceremony on June 27, 2002. Rosie, as she did when MATA first opened, broke through a banner to mark the occasion. (John Landrum.)

On March 20, 2003, in the Cityplace West Village, the Green Dragon is turning from McKinney Avenue onto Cityplace West Boulevard. The new building in the background is a mixed-use development with businesses on the first floor and apartments above. At this time, additional new construction was underway on Cityplace West Boulevard.

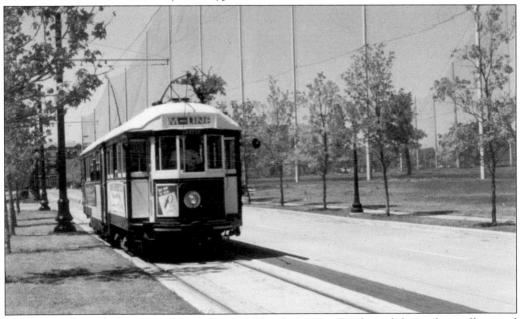

M-Line tracks, which run in the median of Cityplace West Boulevard, keep the trolleys and automobile traffic separated. The area on the right-hand side of this image is the Hank-Haney golf center. In 2011, the center closed, and new streets were being built though the property in advance of even more Uptown development.

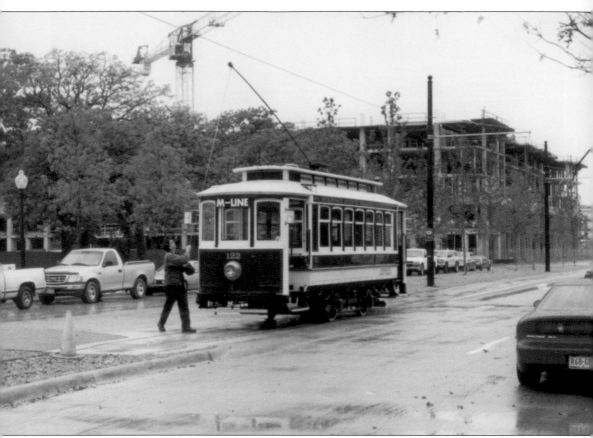

Unlike MATA's other streetcars, little 122 has only one trolley pole. At the end of Cityplace West Boulevard on a rainy November 2002 day, the operator swings Rosie's pole around so she can start her run back to St. Paul Terminal. MATA believes that Rosie is the oldest streetcar in regular revenue service in North America. Used sparingly because of her age, Rosie often provides backup service when other M-Line cars are undergoing repairs. In the Pennsylvania factory where she was built, no one could have imaged that Petunia would still be running 100 years later.

Nine

THE MATA ERA
FORWARD INTO THE FUTURE

Proposition 1 of a Dallas bond package passed by a wide margin on November 7, 2006. This proposition provided money for citywide transportation improvements, including MATA's planned Olive Street extension to the DART downtown Transit Mall.

The M-Line carried over 224,000 riders in 2006. Dallasites were starting to recognize the trolleys as a means of dependable transportation and not just a quaint tourist attraction.

In a May 11, 2007, article, the *Dallas Morning News* reported that in 2006, the trolleys' on-time reliability was 97.5 percent, and as of May 11, 2007, it was almost 100 percent.

The Sue Pope Foundation awarded a grant to air-condition the M-Line trolleys in the spring of 2007. Petunia, Matilda, and the Green Dragon were air-conditioned, but Rosie was not. She is being kept as MATA's "museum car."

On June 21, 2009, restored ex-Dallas streetcar body arrived at the barn. Work began to bring her up to operating condition by installing modern mechanical technology and creature comforts. In 2009, the M-Line was 20 years old, and Rosie was 100. To mark the milestones, a 28-unit parade that included the trolleys marched down McKinney Avenue on September 26.

Ridership kept growing. M-Line president Phil Cobb announced that the trolleys carried 309,000 riders (about 850 per day) in 2009.

On July 8, 2010, the federal government awarded the M-Line a $4.9 million grant, and the North Texas Council of Governments pledged a $5 million matching grant. This money will fund construction of the M-Line's new extension on Olive Street to Federal Street, ending one block from DART's downtown Transit Mall. Trolley tracks will also be installed on Federal Street to connect with an extension to the M-Line's current line on St. Paul Street. This project should be complete in 2014.

In 2010, construction began on a turntable at the end of Cityplace West Boulevard. The turntable and the Olive-Federal-St. Paul loop will allow the M-Line to run single-ended trolleys (like the Toronto PCCs). The improvements have the potential to improve the efficiency and usefulness of the M-Line, boost annual ridership, and make a greater impact on downtown transportation.

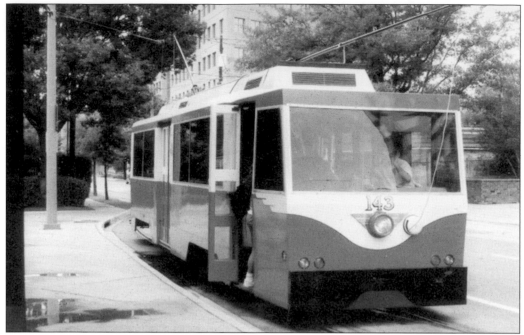

The former Tandy Subway car, now temporary streetcar 143, pauses at McKinney Plaza during its first test run on June 29, 2004. M-Line volunteers, workers, and family members are on board. The car was originally a Washington, DC, streetcar that ran on the short Fort Worth surface/subway line from 1963 until 2002.

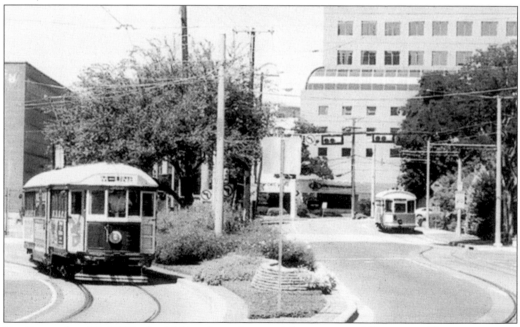

On September 25, 2005, the M-Line hosted a special event to aid Hurricane Katrina victims. Every trolley was pressed into service, and all voluntary fare box contributions were donated to the cause. Matilda is southbound on Allen Street while the northbound Green Dragon in the distance has just entered the curbside tracks on McKinney Avenue.

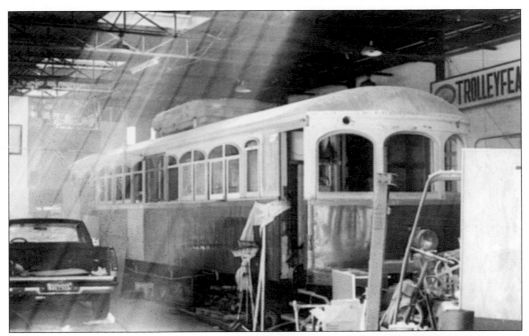

This atmospheric view of interurban 332 was caused by sunlight from the skylights beaming down through exhaust left by Miss Daisy's departure from the carbarn on September 5, 2005. The Morning Star's exterior is painted in the striking blue and red colors of the old Texas Electric Railway's Bluebonnet service.

This 2005 inside view of the interurban shows the artistic touches applied to the car's windows that are crowned with stained glass. Midway in the side of the car is an "invisible" double door that will allow loading whatever table and chairs are needed for a customized party or dining car charter.

The steward's pantry at one end of the Morning Star also has stained glass in its doors. The other end of the interurban will have a bar and there will also be a restroom on board. When complete, this will be the first-class trolley that MATA envisioned her to be.

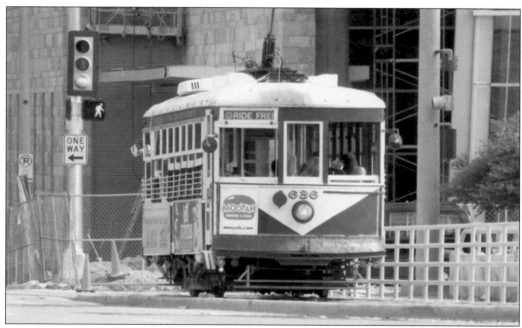

Petunia crosses Woodall Rodgers Freeway in 2005. The construction in the background is typical of the building-and-remodeling boom sweeping Uptown. In 1989, the neighborhood was starting to make a very slow recovery, following a long decline. After the advent of the trolleys, that recovery accelerated. The area soon became one of the fastest-growing residential and commercial sections of Dallas.

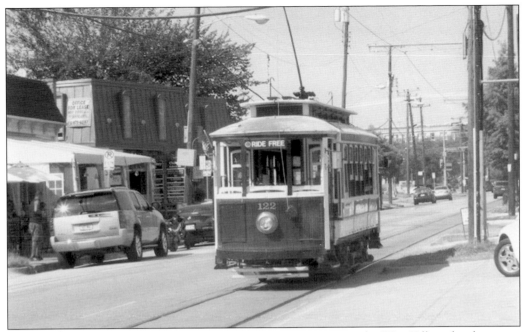

Rosie rumbles down McKinney Avenue in August 2007 en route to the West Village development. The little trolley is not as wide as the other streetcars in the M-Line fleet. That is because Rosie was originally built for Porto, Portugal, which is an old-world European city with very narrow streets.

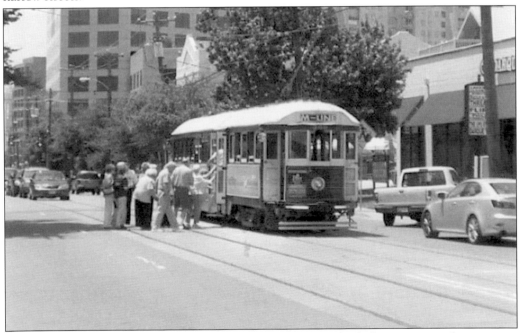

In June 2007, Matilda ties up traffic on McKinney Avenue in both directions as a charter party boards the trolley, after having eaten lunch across the street at one of the many Uptown cafés that feature outside dinning. The seniors in the party are recapturing memories of the days when streetcars were the backbones of public transit.

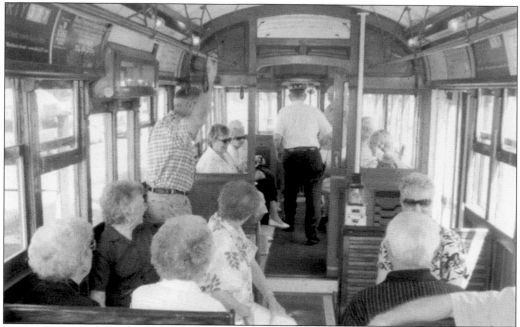

With the charter passengers safely on board, the operator walks to the front of the trolley to get the car moving once again. Matilda's interior is divided into three compartments, separated by beautiful woodwork. It would be almost impossible to find such esthetic craftsmanship in a modern transit vehicle today.

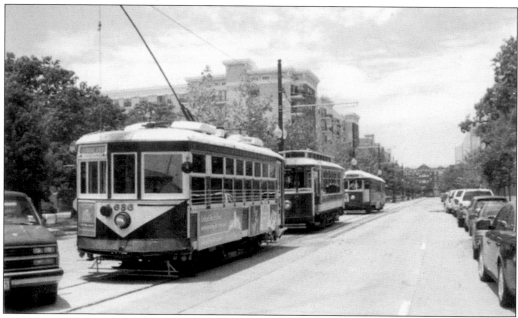

The National Railway Historical Society (NRHS) visited the M-Line on June 19, 2008. The society's three charter cars are lined up at the end of Cityplace West Boulevard. At the same time, the Green Dragon was in birthday charter service. Because this left no dedicated public service car available, regular passengers were allowed to board the NRHS charter cars until the Green Dragon's charter ended.

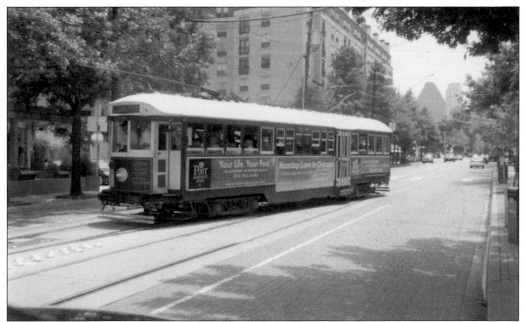

Charter car Matilda went only as far as the crossover on McKinney Avenue, where she reversed direction and transported her load of NRHS members to the carbarn for a guided tour. The other two NRHS charter cars made a round-trip to St. Paul Terminal and back again to Cityplace West.

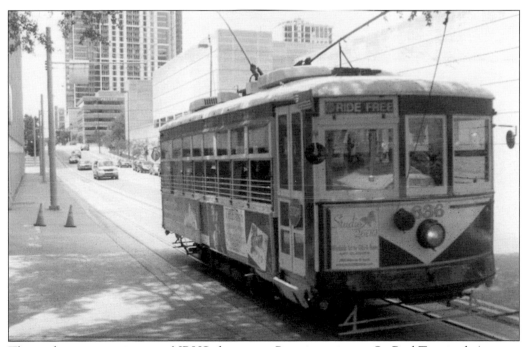

The coolest streetcar in town, NRHS charter car Petunia, arrives at St. Paul Terminal. As a test of the feasibility of air-conditioning the rest of the M-Line fleet, this trolley was the first one to have air-conditioning units mounted on her roof. The units are hardly noticeable and do not detract from Petunia's overall appearance.

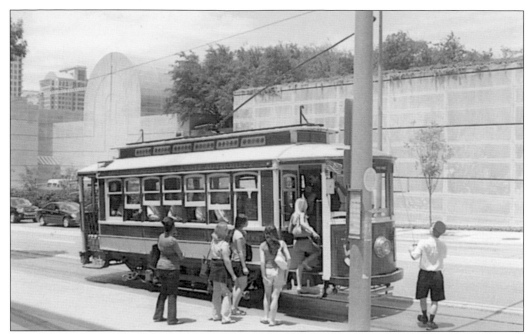

At St. Paul Terminal, while the operator swings Rosie's pole around for a trip back up the line, some passengers attempted to squeeze into the little trolley, already full of conventioneers. They will be able to ride, as there is still standing space available. This illustrates the popularity of the trolleys and the need for more cars.

On June 21, 2009, restored ex-Dallas streetcar body 754, painted in the Dallas Railway & Terminal postwar red and cream colors, was delivered to the carbarn and placed on shop trucks. It will become a fully operational trolley after the installation of her mechanical and electric parts and her permanent trucks.

Trolley 754's interior was also restored to its original configuration before delivery. Creature comforts were not a high priority in 1926 when this car was originally built. Because the 700-series trolleys ran until the end in 1956, DR&T added vinyl padding to the seats of some of them to improve riding comfort.

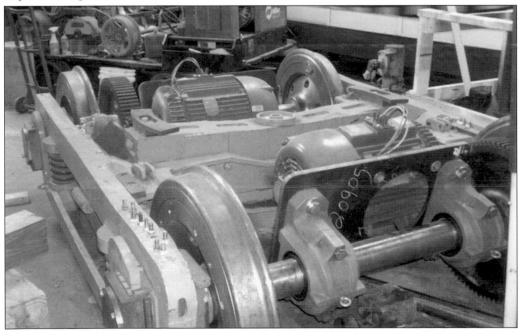

A close-up view of one of 754's new trucks shows her modern motors being installed. If successful, the other trolleys in the M-Line's fleet (except for Rosie) will be retrofitted with similar technology. This fleet of "super trolleys" should make MATA's cars equal to the best modern streetcars that will run on a second trolley line planned for Dallas.

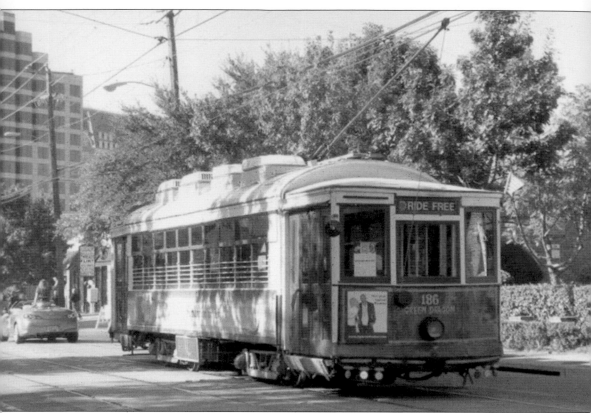

On September 26, 2009, the M-Line celebrated its 20th anniversary and Rosie's 100th birthday. Because the M-Line opened with a parade, it was only natural that the anniversary and birthday be marked with another parade down McKinney Avenue. The trolleys and volunteer Earl Leeson's hi-rail truck were staged on Allen Street. The other parade units lined up on Oak Grove Avenue. The first trolley in the parade was the Green Dragon. Even though her air-conditioners are quite obvious, she manages to cater to the rigors of a Texas summer while maintaining her historic charm. This car is one of the very few Stone and Webster turtleback trolleys still running. (John Morris.)

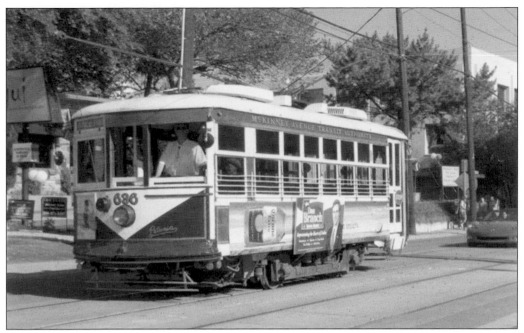

Birney trolley Petunia was the next trolley in the parade. During the first Dallas trolley era, she actually ran on McKinney Avenue to the Oak Lawn line in regular revenue service, but not to this much fanfare. Oak Lawn riders complained when the PCCs replaced the Birneys, because the latter had provided more frequent service. (John Morris.)

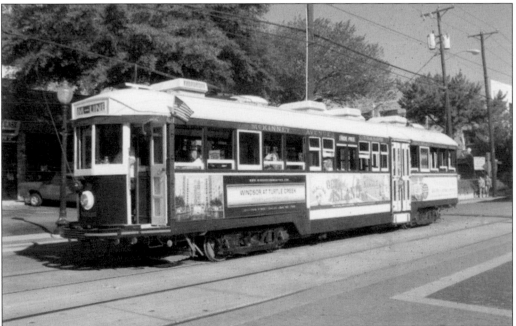

Rolling down the Avenue in the parade, Majestic Matilda was the mistress of all she surveyed. Although built in Australia in 1926, the big trolley seems right at home in America and is still going strong at the ripe old age of 83. The Gomaco Company of Iowa has rebuilt several of her sisters for heritage trolley lines in the United States. (John Morris.)

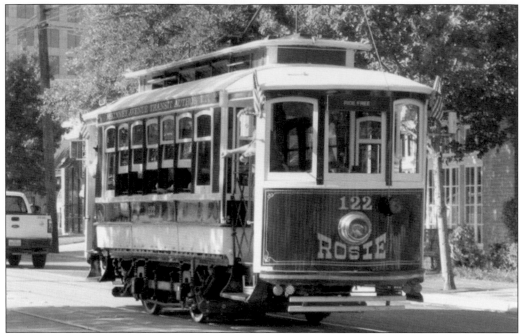

The M-Line saved the best for last. Although she led the opening-day parade in 1989, MATA's first trolley—octogenarian Rosie—provided a fitting climax to the birthday celebration. Thanks to the tender loving care lavished on her by M-Line volunteers, this turn-of-the-20th-century trolley still runs today. (John Morris.)

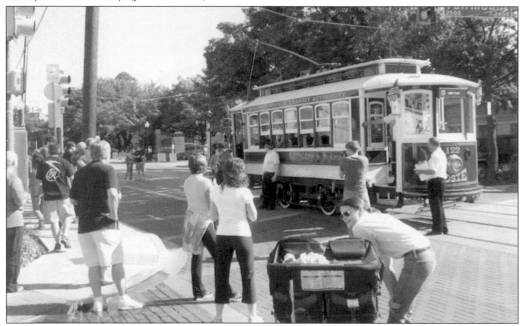

At McKinney Avenue and Fairmount Street, a small crowd gathered and sang "Happy Birthday" to Rosie. A local artist had recently painted each trolley's name on the car's ends. Rosie's name really stands out. This little gem is looking good, running well, and should have many more years of reliable service.

It is 2010, and modern automobiles have to share the road with an ancient streetcar named Matilda. Cole Avenue marks the western boundary of the West Village. Some drivers complain that the M-Line trolleys hold up traffic, while others love the trolleys and understand the great benefits they bring to Uptown. (MATA Collection.)

Workers at the site of minor track or street repairs have to take a break when a trolley rumbles through the construction zone. The pavement on McKinney Avenue in this May 2010 scene is the new concrete brick that replaced original worn-out bricks when the avenue was rebuilt in 1999–2000.

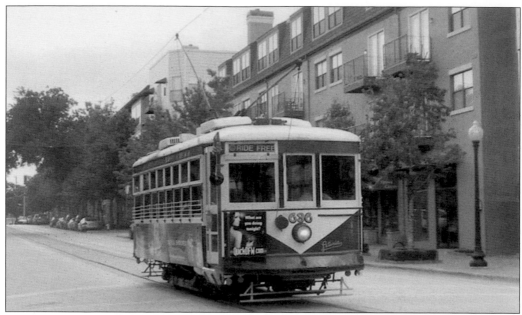

On Cole Avenue, Petunia approaches Hall Street in May 2010. The apartments beside her are an example of Uptown's phenomenal growth that began after the trolleys started rolling through the neighborhood. Uptown is the home to many young professionals and is considered the most pedestrian-friendly part of Dallas.

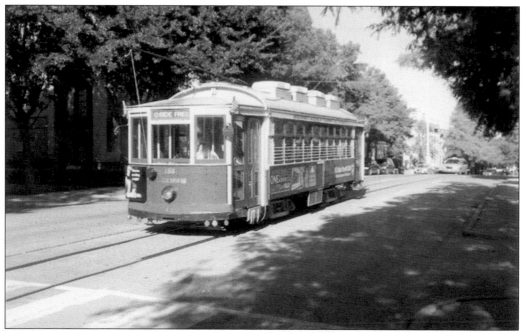

The Green Dragon rolls down Allen Street on a pleasant October day in 2010. When the trolley line was first built, the land to her right was an undeveloped, vacant lot. It is now home to a mix of residential and retail buildings. The uniqueness of the M-Line was a major catalyst in Uptown's revival.

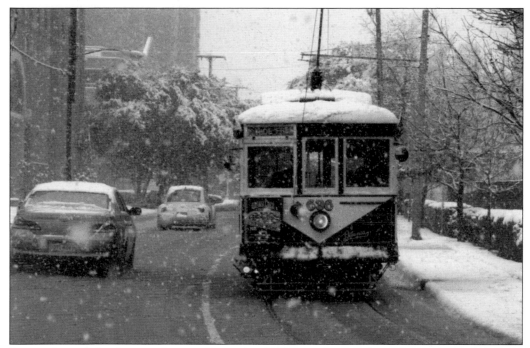

Petunia braved the elements during a December 2010 snow that mostly stuck to grassy and elevated areas. Although sometimes unable to maintain their regular schedules, the trolleys kept running during the heavy snow and ice storms that played havoc with rubber-tired traffic all over the city the following January. (Margaret Canady.)

Even sturdy, 84-year-old Matilda, MATA's newest operating trolley, needs regular maintenance to keep her going. In the spring of 2011, one side of her body that had been showing signs of wear and tear was rebuilt. The rush job was completed in only three weeks. (Mike Sullivan.)

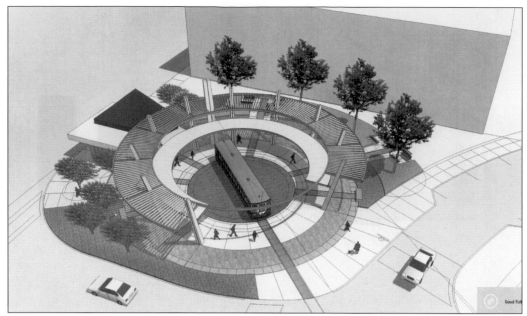

An artist's rendering of the new turntable at the end of Cityplace West Boulevard shows it will be an architectural asset to the city. It will also provide a paved pedestrian walkway from the DART subway entrance building to the trolley boarding area on the boulevard. As of spring 2011, work is underway on the project. (Good Fulton & Farrell Architects.)

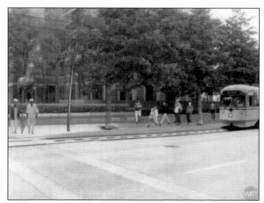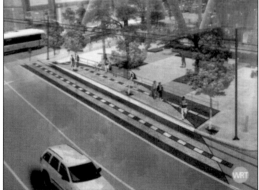

These drawings provide a preview of the M-Line's proposed extension on Olive Street. The line will run through the heart of the Arts District and the deck park being built over Woodall Rodgers Freeway. The extension is scheduled to open in the summer of 2012. Not only is MATA getting older, it is getting better! (Huitt-Zollars.)

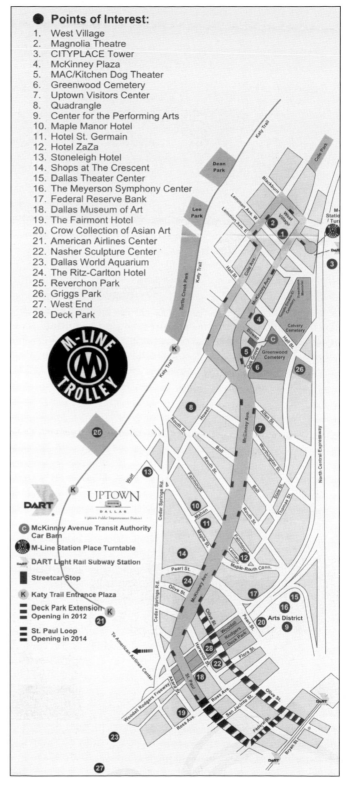

Points of Interest:

1. West Village
2. Magnolia Theatre
3. CITYPLACE Tower
4. McKinney Plaza
5. MAC/Kitchen Dog Theater
6. Greenwood Cemetery
7. Uptown Visitors Center
8. Quadrangle
9. Center for the Performing Arts
10. Maple Manor Hotel
11. Hotel St. Germain
12. Hotel ZaZa
13. Stoneleigh Hotel
14. Shops at The Crescent
15. Dallas Theater Center
16. The Meyerson Symphony Center
17. Federal Reserve Bank
18. Dallas Museum of Art
19. The Fairmont Hotel
20. Crow Collection of Asian Art
21. American Airlines Center
22. Nasher Sculpture Center
23. Dallas World Aquarium
24. The Ritz-Carlton Hotel
25. Reverchon Park
26. Griggs Park
27. West End
28. Deck Park

McKinney Avenue Transit Authority Car Barn

M-Line Station Place Turntable

DART Light Rail Subway Station

Streetcar Stop

Katy Trail Entrance Plaza

Deck Park Extension Opening in 2012

St. Paul Loop Opening in 2014

This map shows the M-Line route and neighborhood map.

www.arcadiapublishing.com

Discover books about the town where you grew up, the cities where your friends and families live, the town where your parents met, or even that retirement spot you've been dreaming about. Our Web site provides history lovers with exclusive deals, advanced notification about new titles, e-mail alerts of author events, and much more.

Find Your Place in History.